HIS FACE

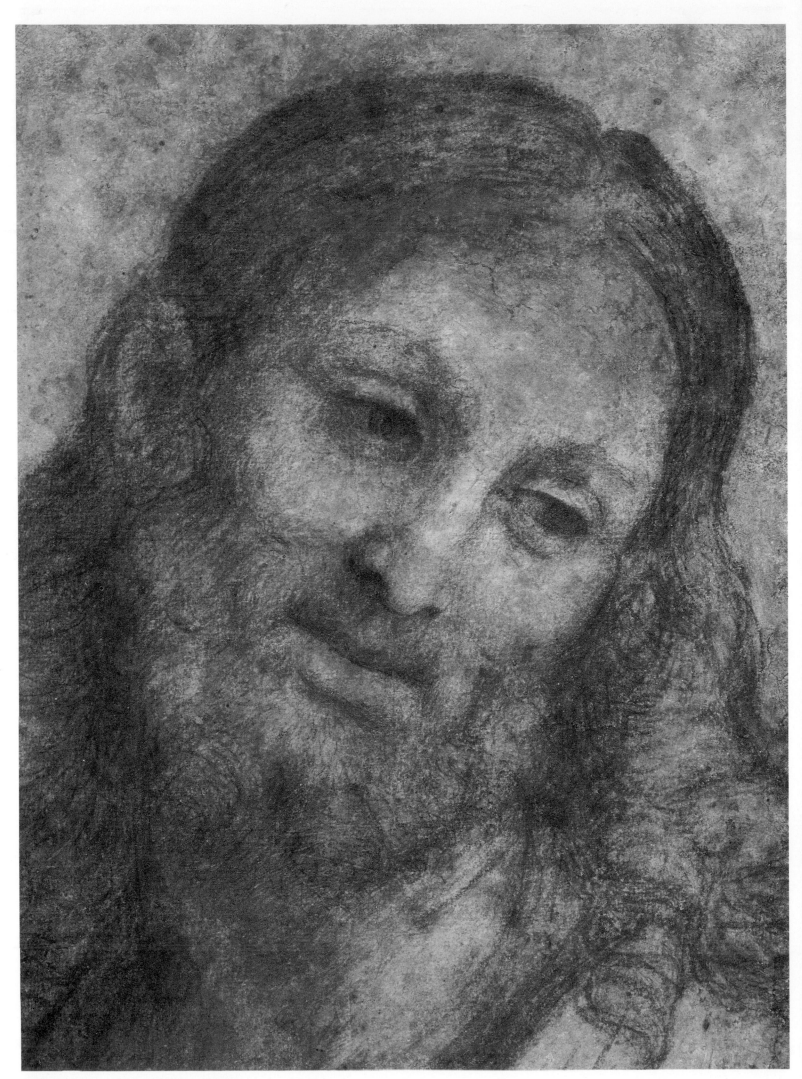

BERNARDINO LUINI, *BUST OF CHRIST*

HIS FACE

Images of Christ
in Art

Selections from
THE KING JAMES VERSION OF THE BIBLE

Edited by Marion Wheeler

SMITHMARK

© Copyright 1988 by Chameleon Books, Inc.

All rights reserved. No part of this publication may be reproduced, stored in a retrieval system or transmitted in any form or by any means electronic, mechanical, photocopying or otherwise without first obtaining written permission of the copyright owner.

This edition published in 1996 by
SMITHMARK Publisher,
a division of U.S. Media Holdings, Inc.,
16 East 32nd Street
New York, NY 10016.

SMITHMARK books are available
for bulk purchase for sales promotion and premium use.
For detail write or call the manager of special sales,
SMITHMARK Publishers, 16 East 32nd Street
New York, NY 10016 (212) 532-6600.

Produced by
Chameleon Books, Inc.
211 West 20th Street
New York, NY 10011

ISBN: 0-7651-9709-X

Printed and bound by
O. G. Printing Productions, Ltd.
Hong Kong.

10 9 8 7 6 5 4 3 2 1

Contents

EDITOR'S PREFACE

*H*istorically, Jesus Christ's physical appearance remains a mystery. No one knows what he actually looked like. Nowhere in the gospels is he described, and no likeness of him of any kind in any form can be dated conclusively to the years of his life on earth. Yet his face is the most familiar and recognizable in Western iconography.

For centuries, rendering the essential qualities of Christ's divinity and humanity has dominated the creative energies and imaginations of the world's artists—from early unknown painters to the most celebrated masters. And, although each artist's conception is an individual representation of Christ, and each image may differ in terms of specific physical characteristics, the image portrayed is always immediately identifiable as that of Christ. For, although he is represented as a man among men, women, and children, the face of Christ, as rendered by the great painters, always reflects the unique dual nature of Christ as God and man. The result of this considerable artistic achievement is a legacy of visions of Jesus Christ that is at once aesthetically magnificent and spiritually enriching.

The idea for this book came after visiting the great art collections in America and Europe. So many of the faces of Christ remained vivid in our minds long after the memory of the paintings in which they appear had faded. Who could forget the gravely triumphant image of the resurrected Christ as painted by Piero della Francesca? Or Paolo Veronese's compassionate yet sorrowful Christ carrying the cross? Or Raphael's innocent yet preternaturally wise infant Jesus? The power of these images remains long after they are first seen and is renewed each time they are seen again, even in reproductions.

The choice of images in this book is necessarily arbitrary. It does not attempt to be anything other then a representative selection from the thousands of depictions of Jesus Christ in art. Those selected date from the twelfth century through the twentieth. Italian, Spanish, French, German, Dutch, and Flemish artists predominate simply because they produced so many of the most spiritually compelling and inspiring portraits of Christ.

Grateful acknowledgment is made to all those who helped produce this book; special thanks are owed to John Roberts and Joel Rosenman, Astrid Seeburg, Alan Kanterman, Joseph Lada, Roberta Halpern, Marilee Talman, Stephen Frankel, and Perry Brooks for their invaluable assistance.

M.W.

HIS YOUTH

Behold, a virgin shall be with child, and shall bring forth a son, and they shall call his name Emmanuel, which being interpreted is, God be with us. MATTHEW 1:23

GEORGES DE LA TOUR, *THE NATIVITY*

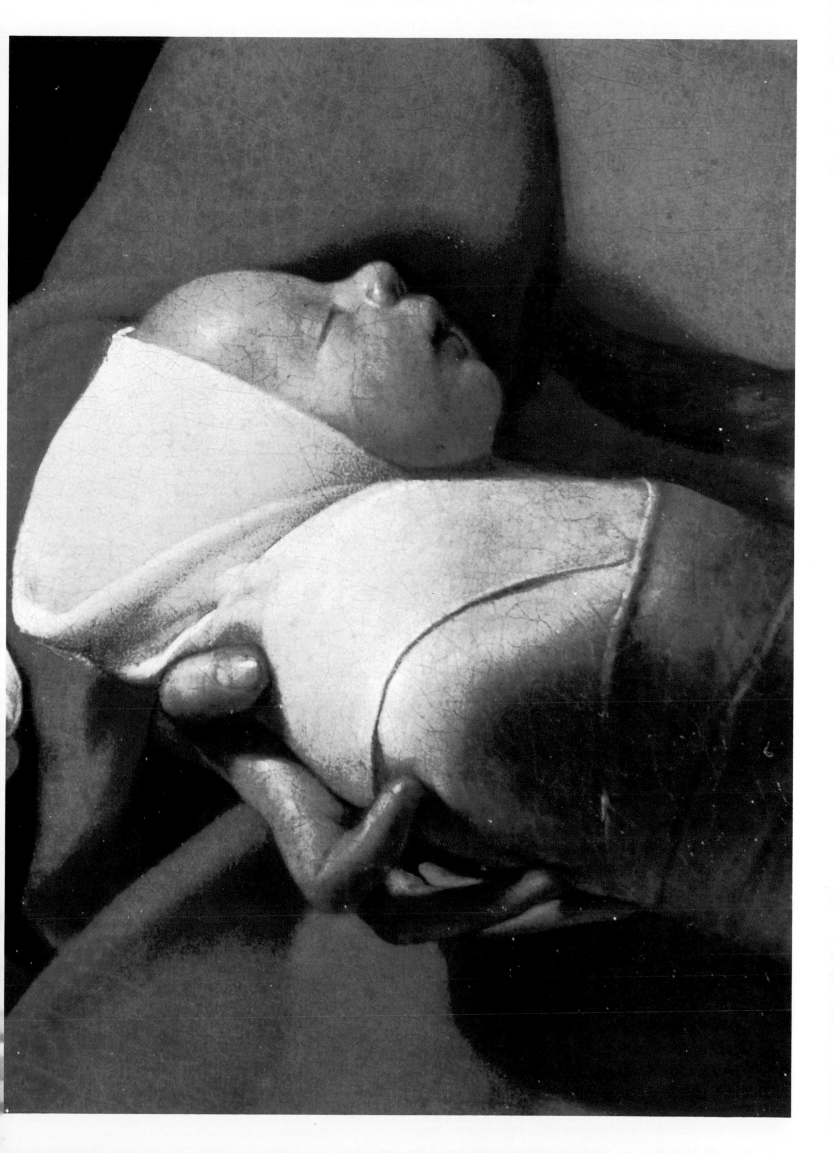

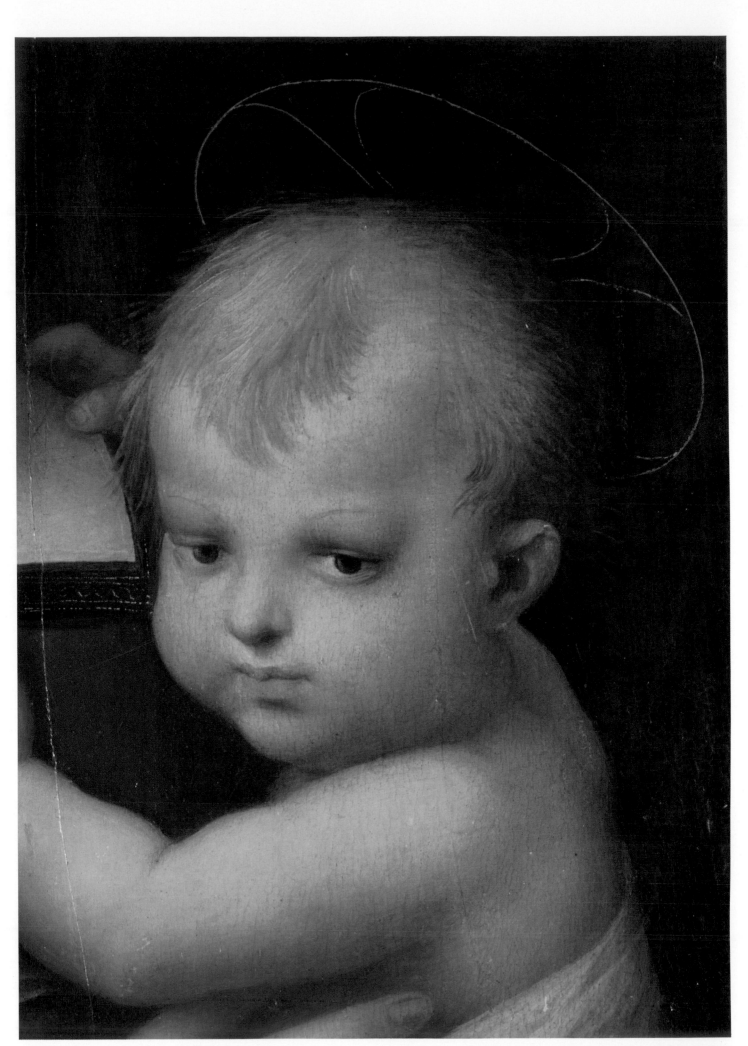

RAPHAEL, *MADONNA OF THE GRAND DUKE*

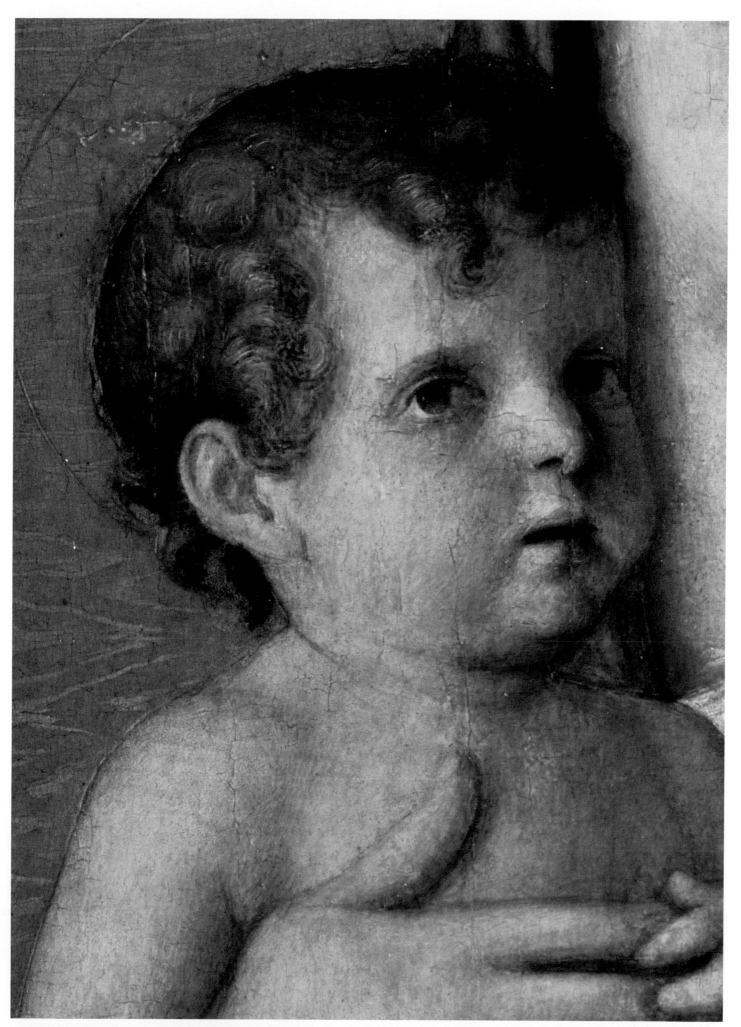

GIOVANNI BELLINI, *MADONNA DEGLI ALBERELLI*

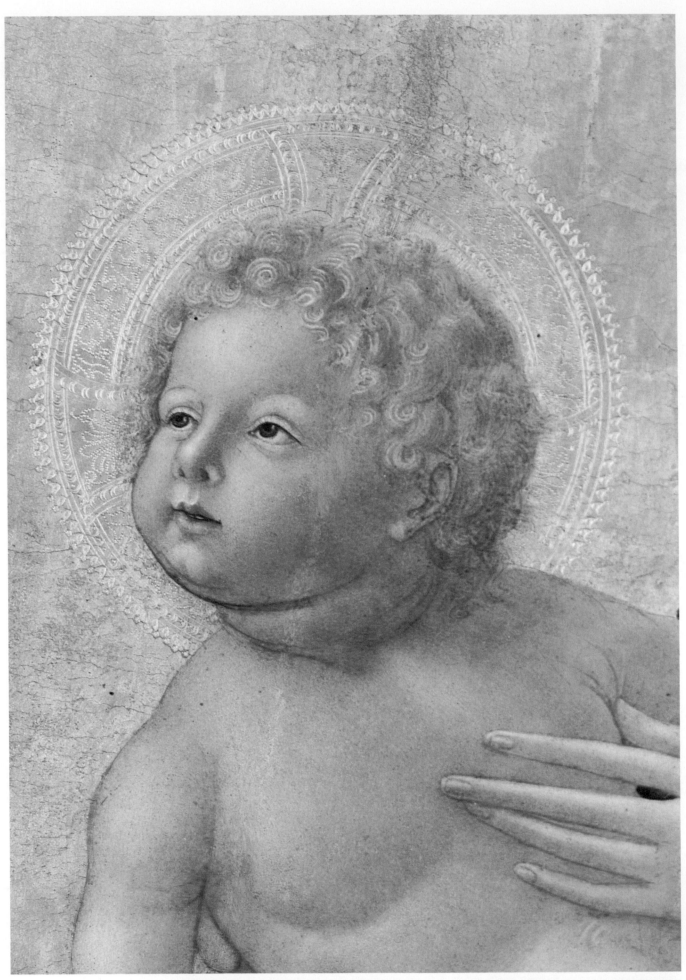

NEROCCIO, *MADONNA AND CHILD WITH ST. ANTHONY ABBOT AND ST. SIGISMUND*

12

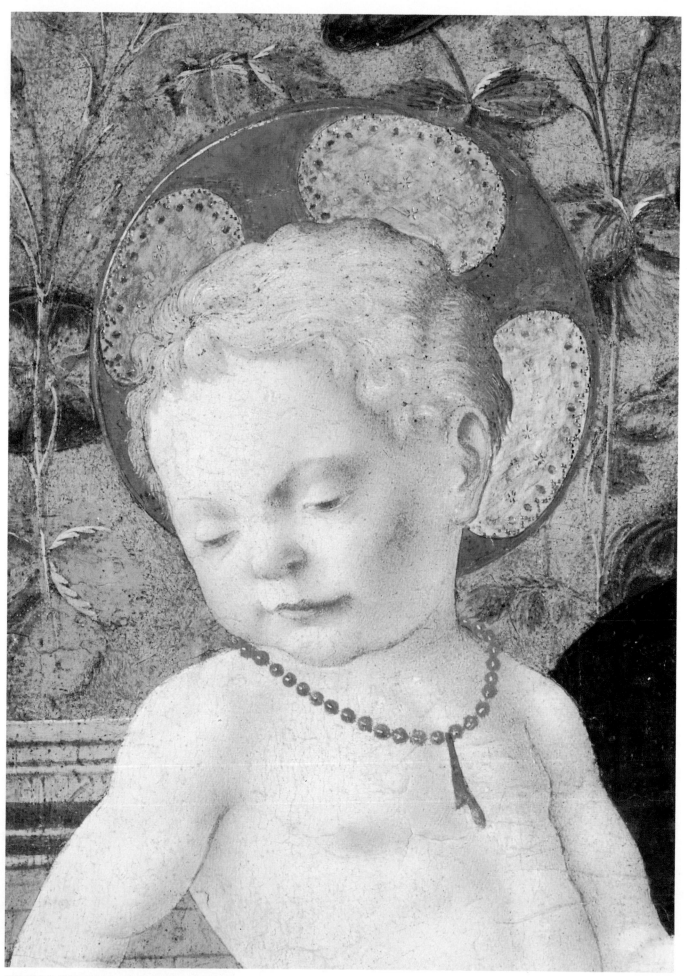

SCHOOL OF PIERO DELLA FRANCESCA, *VIRGIN AND CHILD WITH ANGELS*

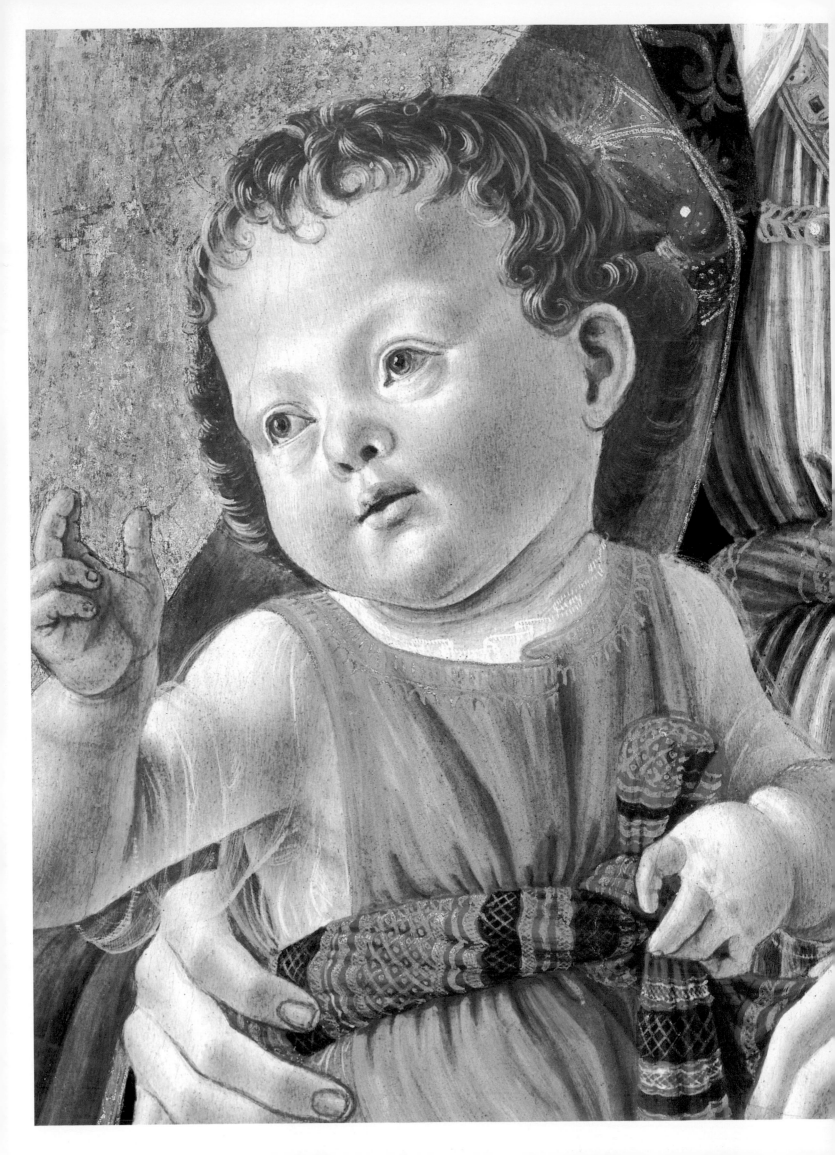

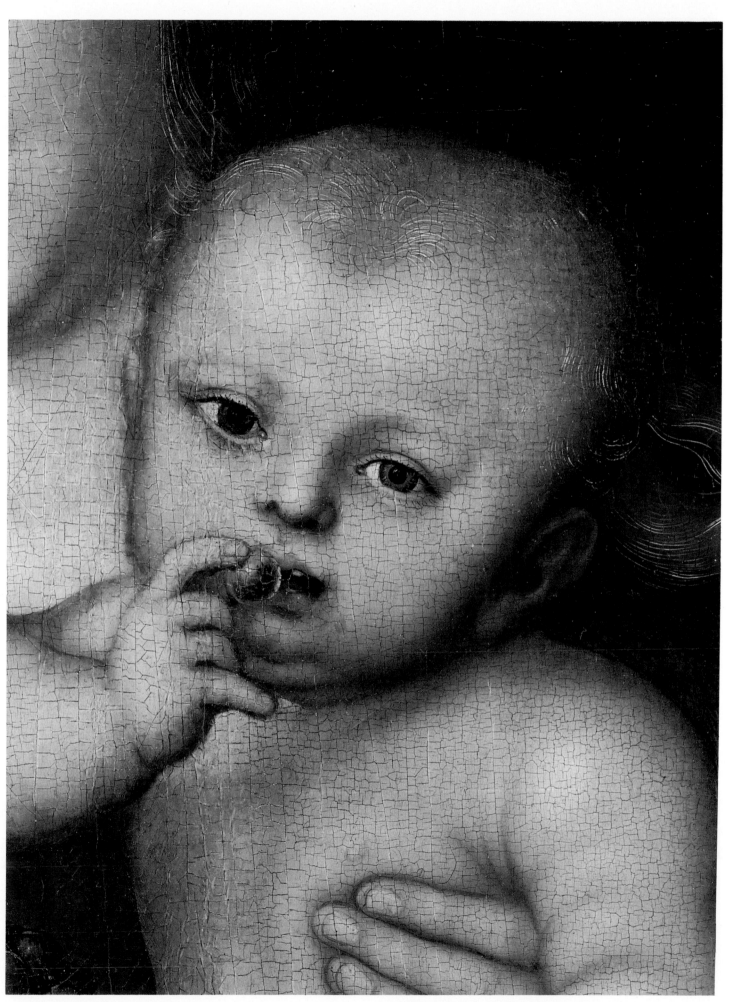

LUCAS CRANACH THE ELDER, *MADONNA AND CHILD*

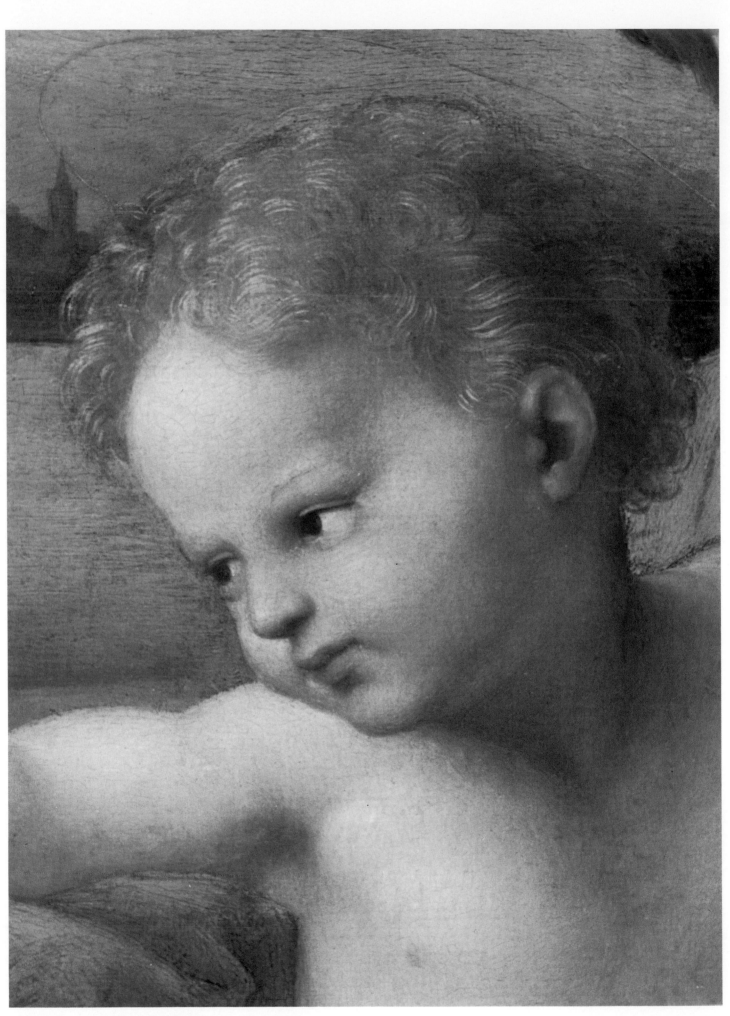

RAPHAEL, *THE ALBA MADONNA*

GIOVANNI BATTISTA TIEPOLO, *MADONNA OF THE GOLDFINCH*

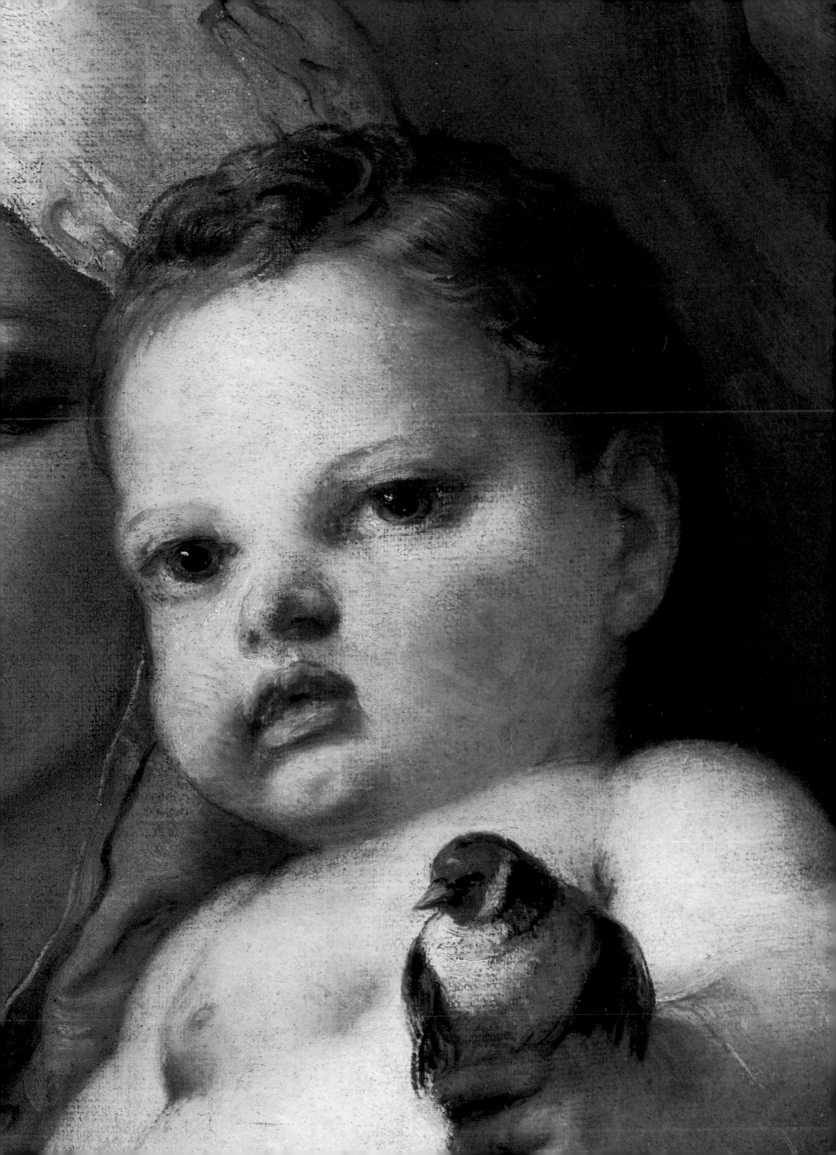

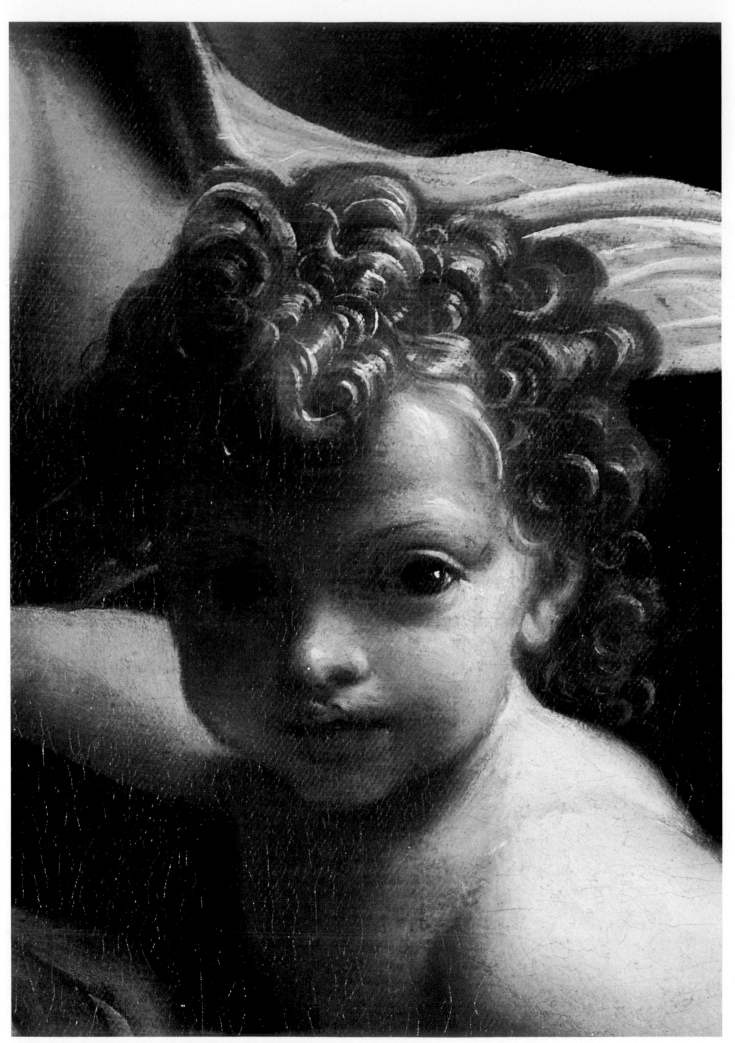

LUDOVICO CARRACCI, *THE DREAM OF ST. CATHERINE OF ALEXANDRIA*

MICHELANGELO CARAVAGGIO, *MADONNA DEI PALAFRENIERI*

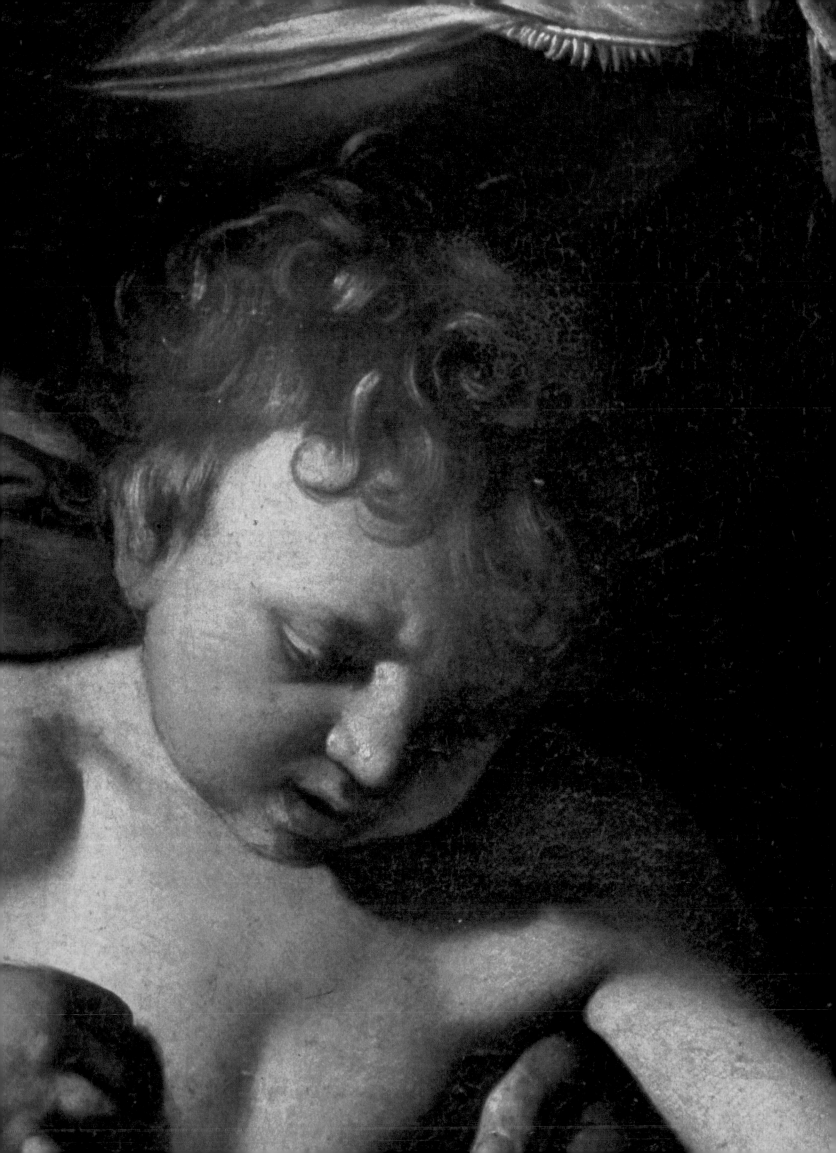

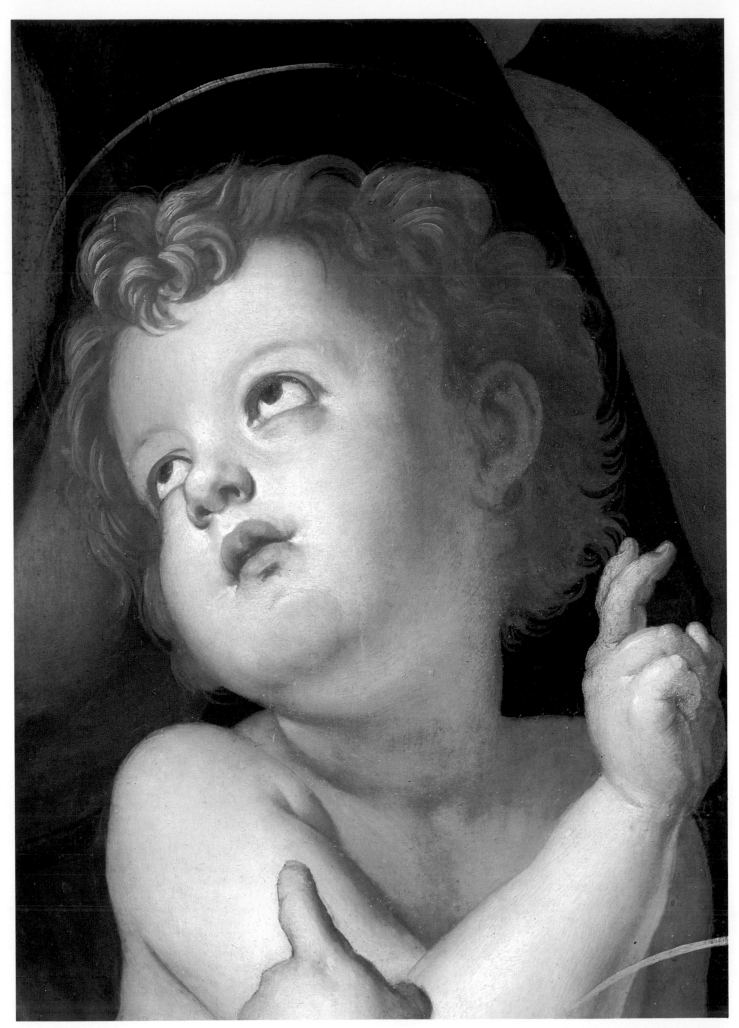

PONTORMO, *THE HOLY FAMILY*

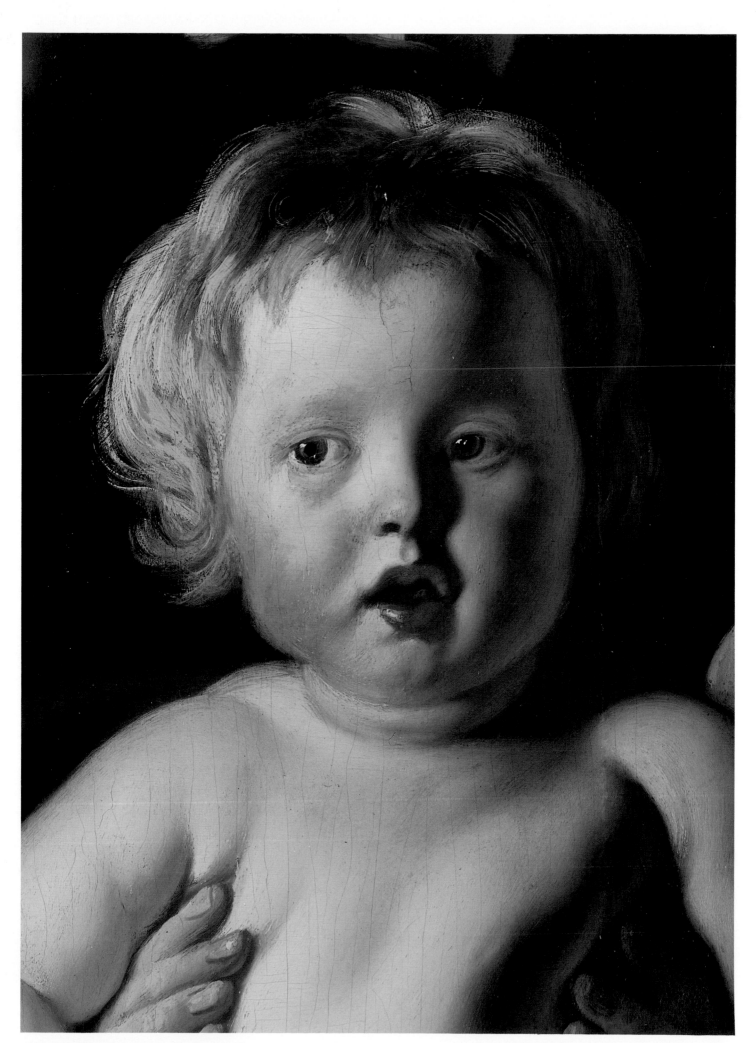

JACOB JORDAENS, *HOLY FAMILY*

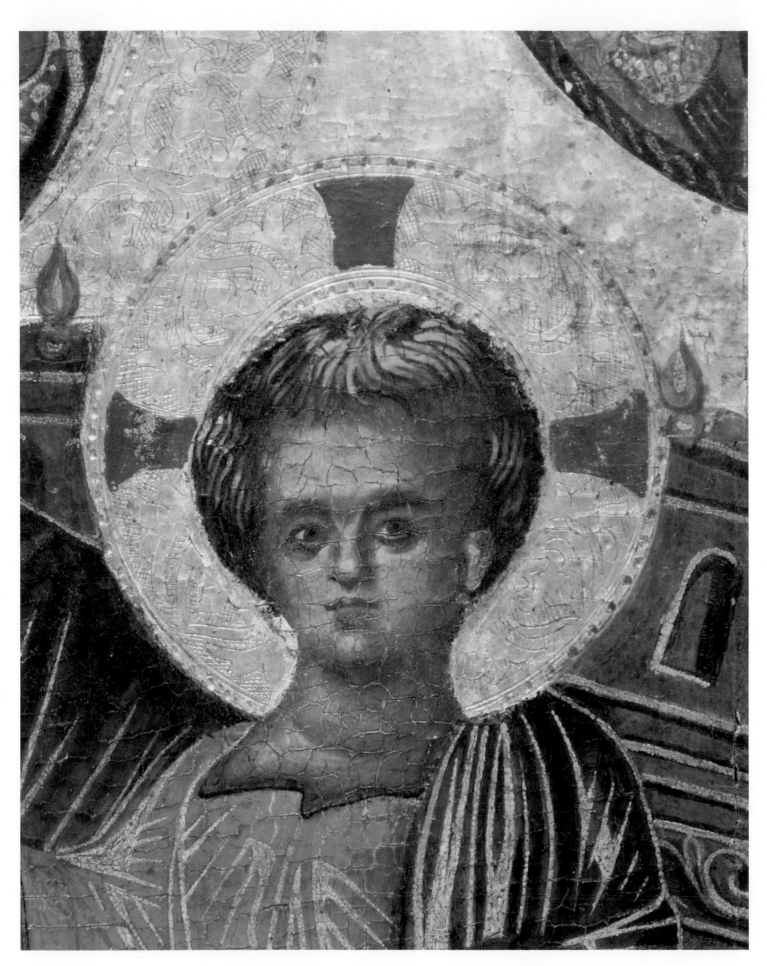

MARGARITONE, *MADONNA AND CHILD ENTHRONED*

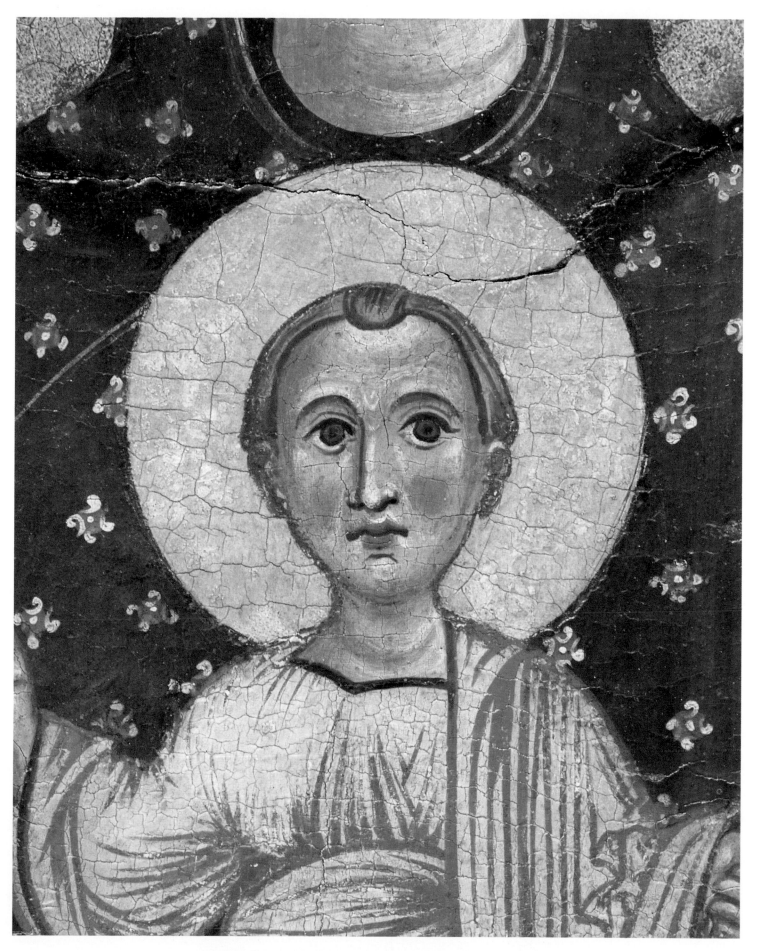

BYZANTINE, *MADONNA AND CHILD ON A CURVED THRONE*

*A*nd the child grew, and waxed strong in spirit, filled with wisdom: and the grace of God was upon him. LUKE 2:40

GEORGES DE LA TOUR, *ST. JOSEPH, THE CARPENTER*

*A*nd when he was twelve years old, they went up to Jerusalem after the custom of the feast. And when they had fulfilled the days, as they returned, the child Jesus tarried behind in Jerusalem; and Joseph and his mother knew not of it. LUKE 2:42–43

*A*nd it came to pass, that after three days they found him in the temple, sitting in the midst of the doctors, both hearing them, and asking them questions. And all that heard him were astonished at his understanding and his answers. LUKE 2:46–47

MASTER OF THE CATHOLIC KINGS, *CHRIST AMONG THE DOCTORS*

ALBRECHT DURER, *CHRIST AMONG THE DOCTORS*

WILLIAM HOLMAN HUNT, *THE FINDING OF THE SAVIOUR IN THE TEMPLE*

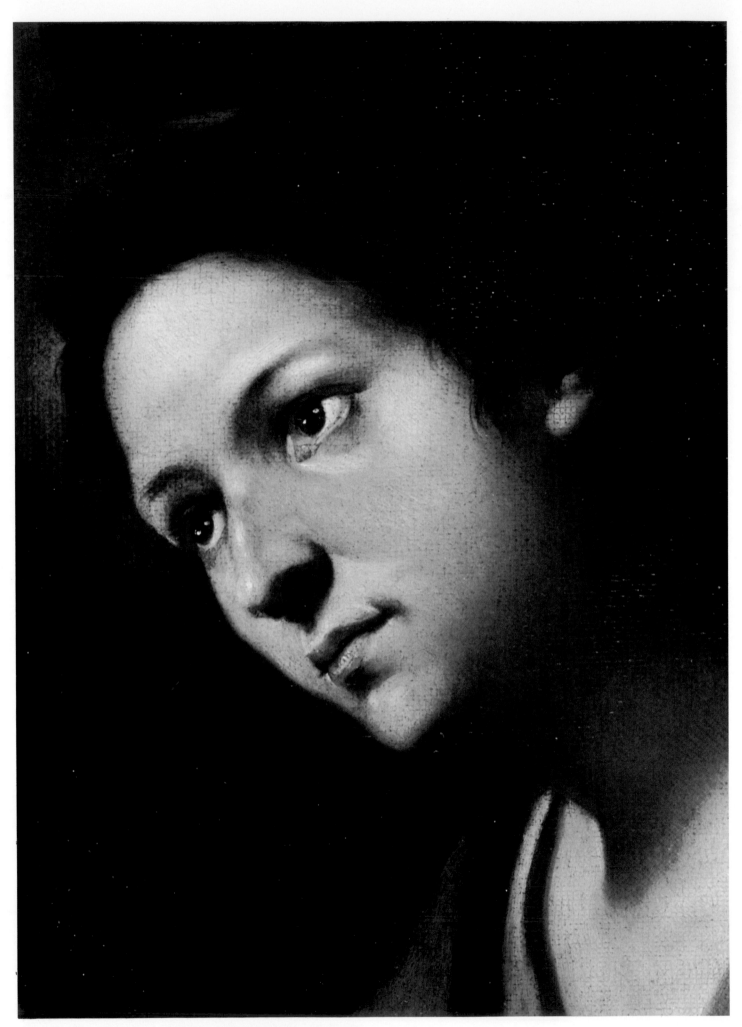

NEAPOLITAN SCHOOL, *CHRIST DISPUTING THE DOCTORS*

JEAN LECLERC, *CHRIST AMONG THE DOCTORS*

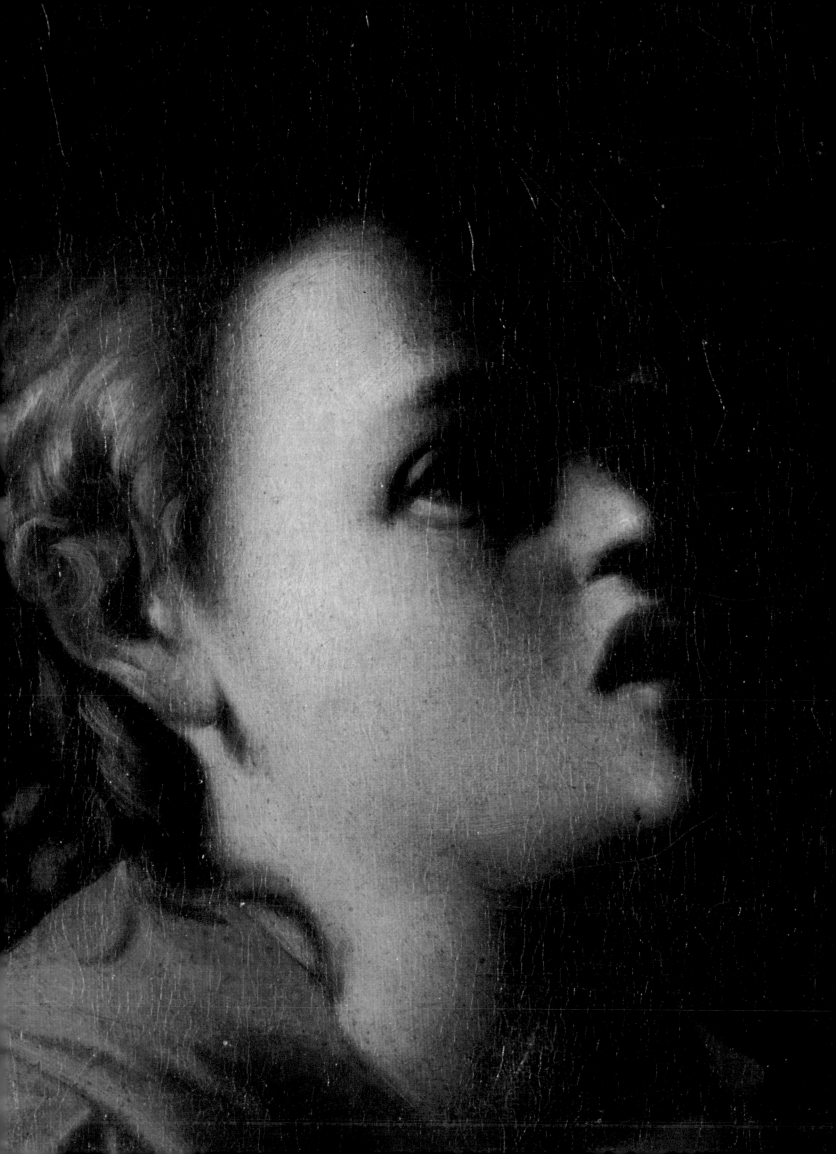

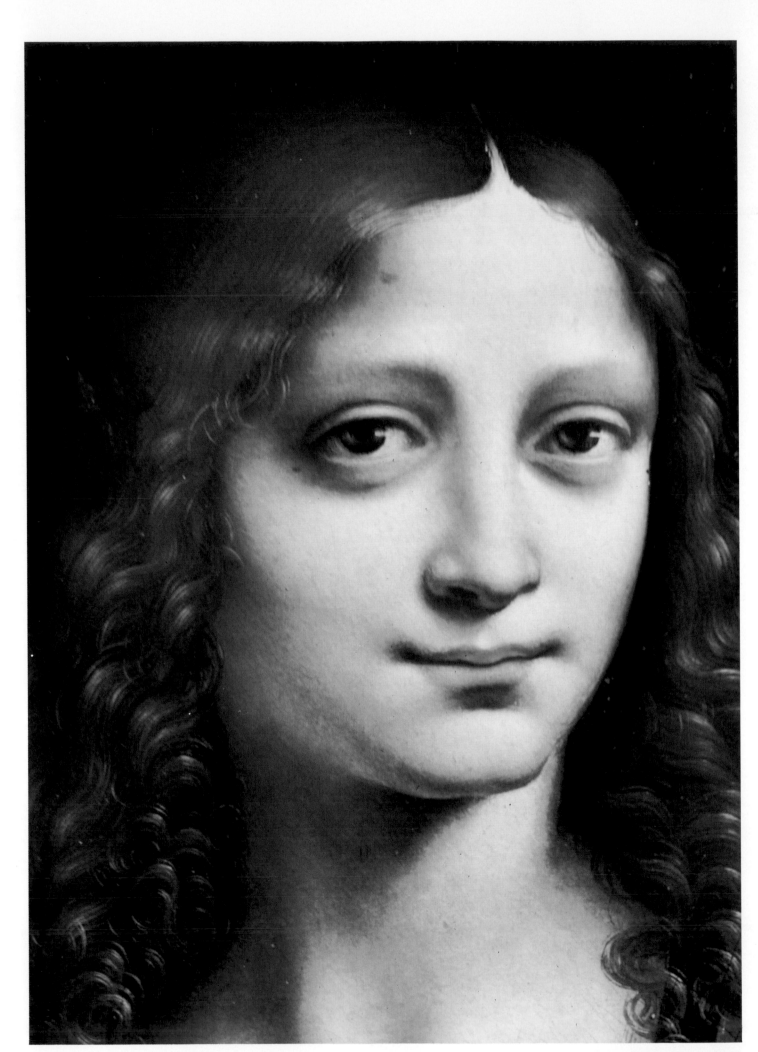

MARCO D'OGGIONO, *THE SAVIOR*

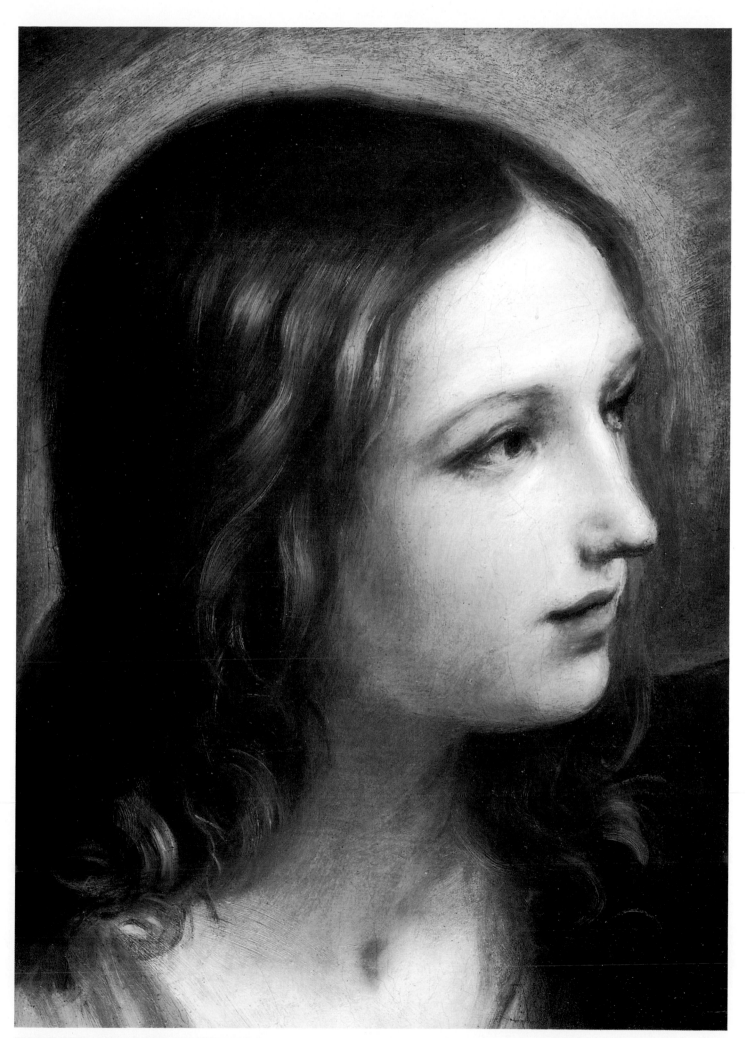

GUIDO RENI, *JESUS EMBRACING ST. JOHN*

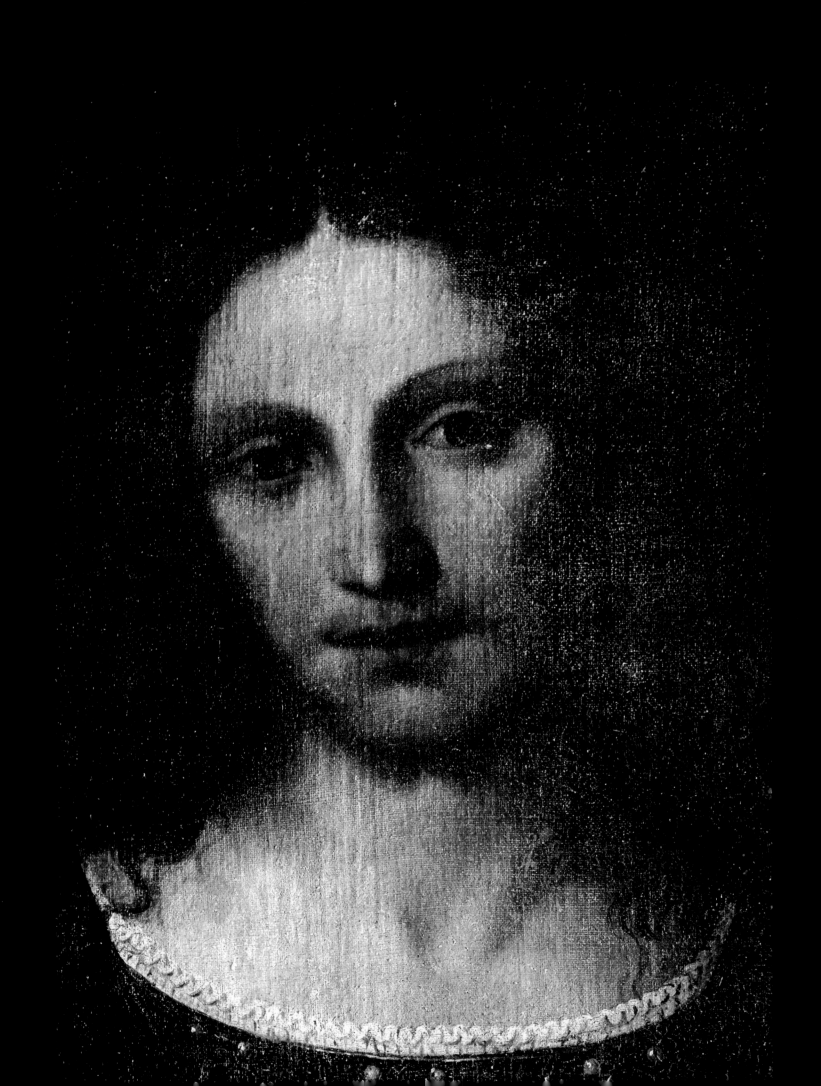

And Jesus increased in wisdom and stature, and in favor with God and man. LUKE 2:52

HIS MINISTRY

And it came to pass in those days, that Jesus came from Nazareth of Galilee, and was baptized of John in Jordan. And straightway coming up out of the water, he saw the heavens opened, and the Spirit like a dove descending upon him: And there came a voice from heaven, saying, Thou art my beloved Son, in whom I am well pleased. MARK 1:9–11

GIOTTO, *THE BAPTISM OF CHRIST BY ST. JOHN THE BAPTIST*

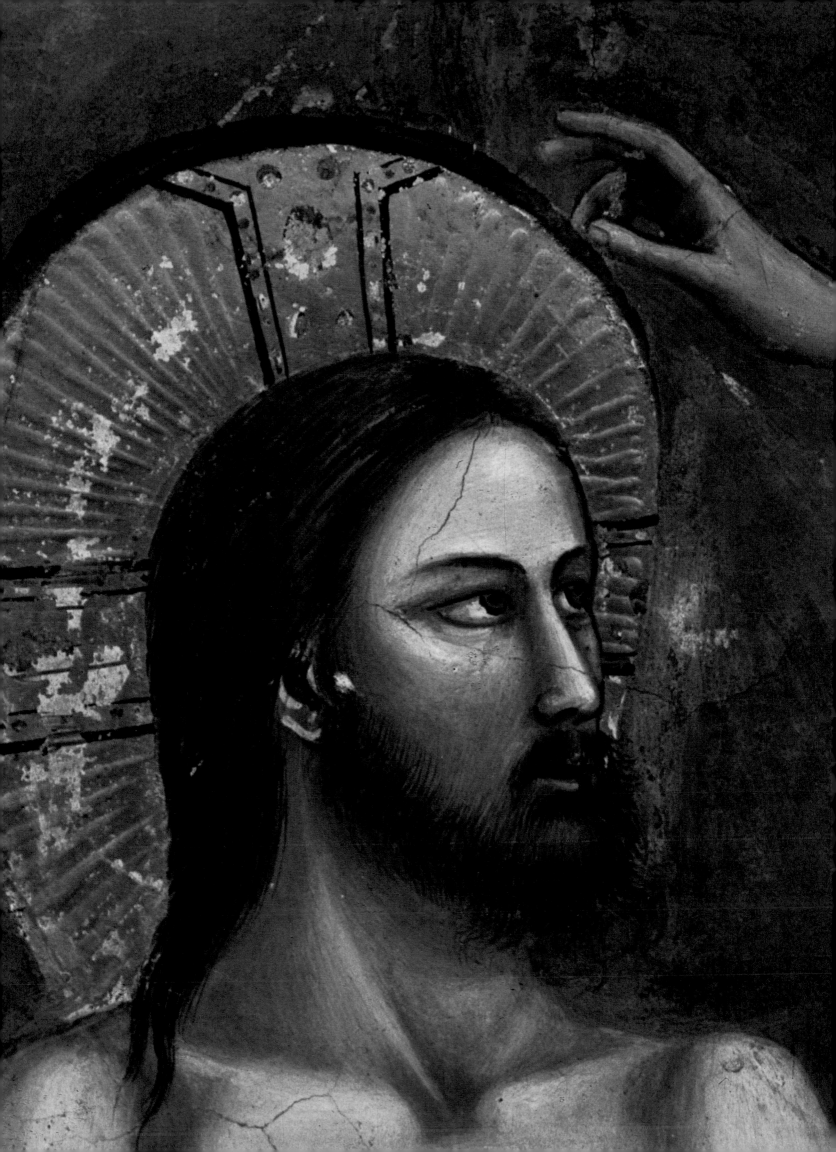

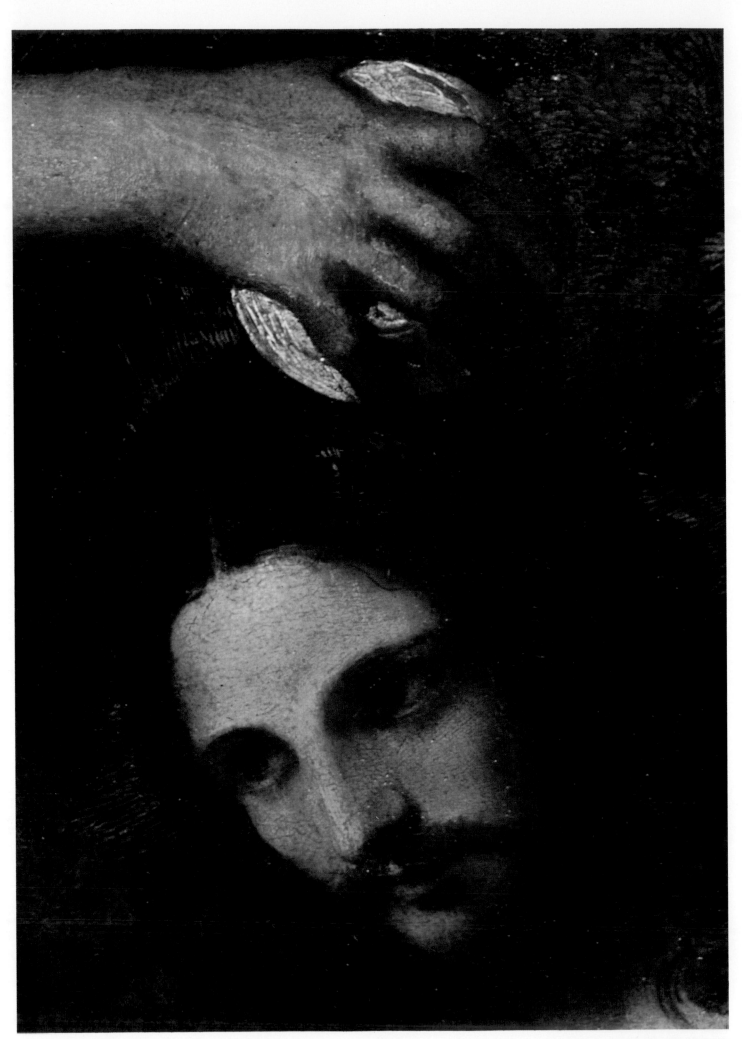

TITIAN, *BAPTISM OF CHRIST*

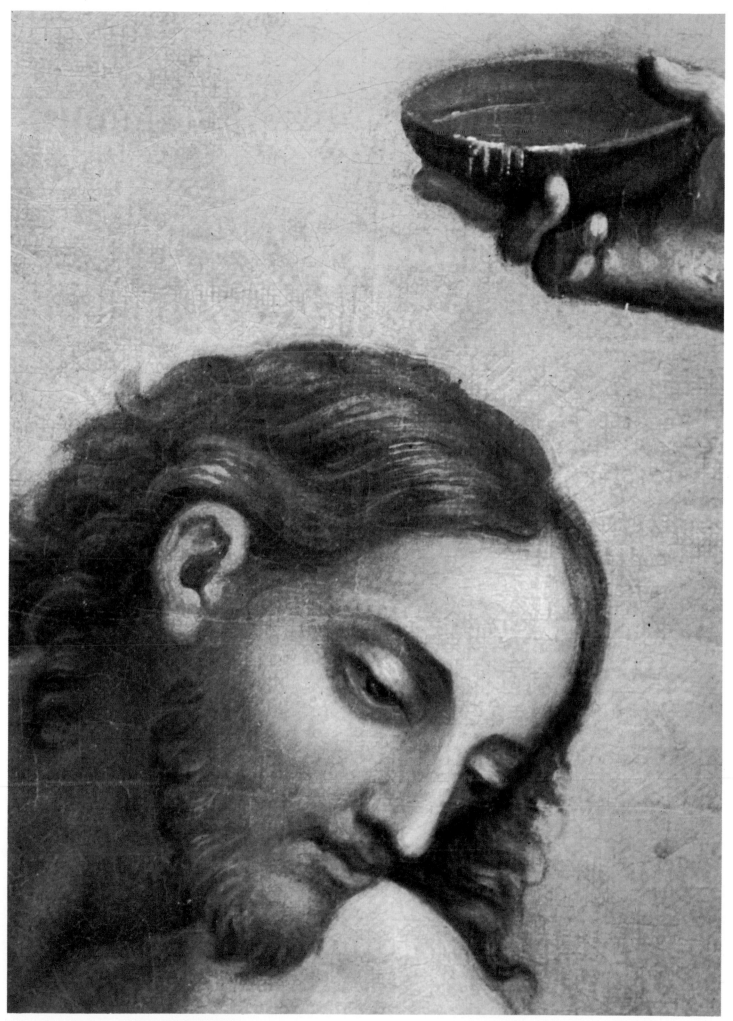

HENDRIK KROCK, *BAPTISM OF CHRIST*

And he was there in the wilderness forty days tempted of Satan; and was with the wild beasts; and the angels ministered unto him. MARK 1:13

GET THEE BEHIND ME, SATAN: FOR IT IS WRITTEN, THOU SHALT WORSHIP THE LORD THY GOD, AND HIM ONLY SHALT THOU SERVE. JOHN 4:8

TITIAN, *TEMPTATION OF CHRIST*

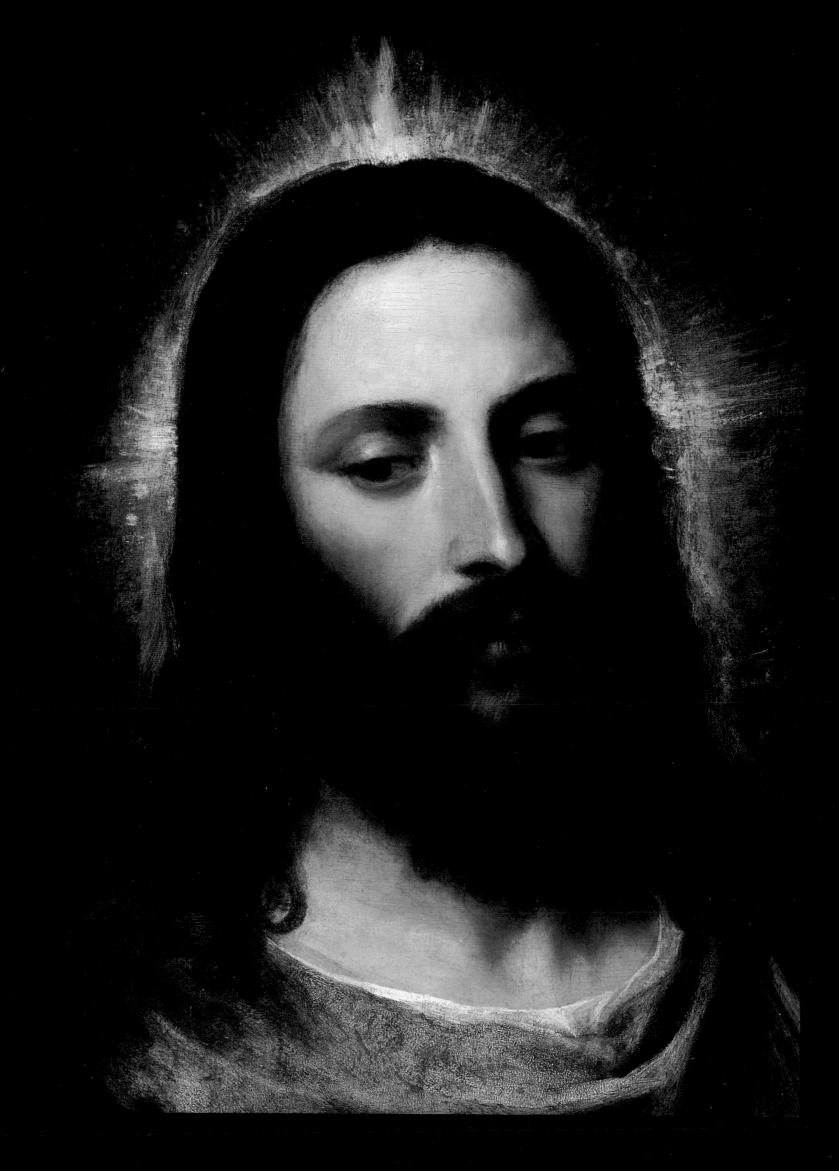

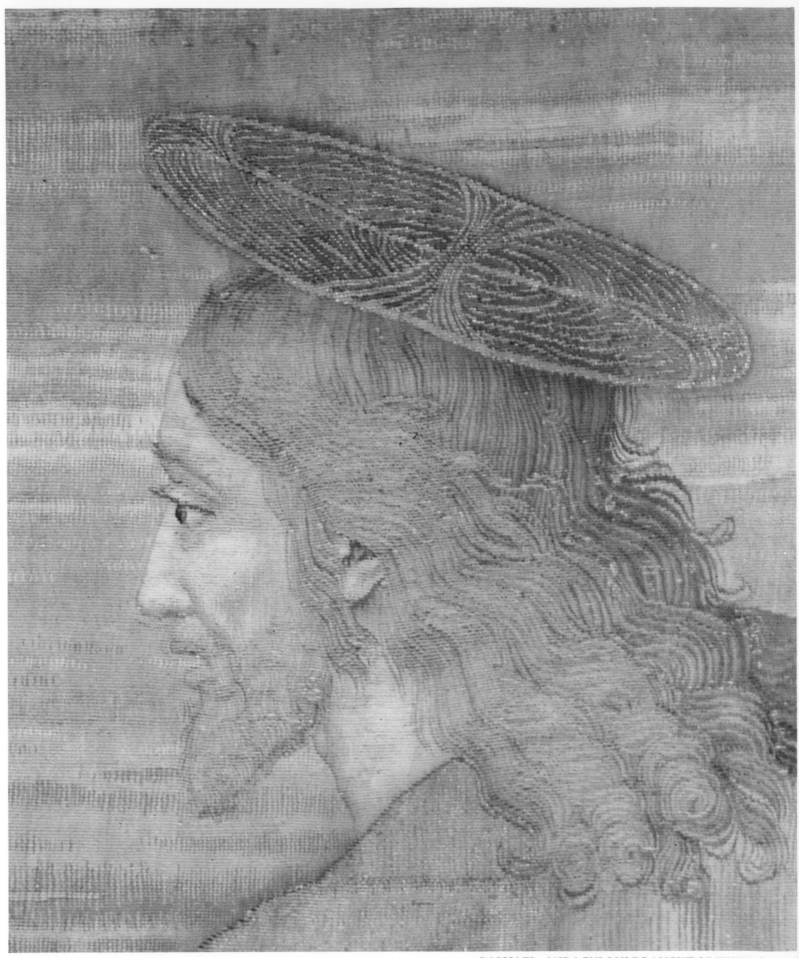

RAPHAEL, *MIRACULOUS DRAUGHT OF FISHES* (tapestry)

FOLLOW ME, AND I WILL MAKE YOU FISHERS OF MEN. MATTHEW 4:19–20

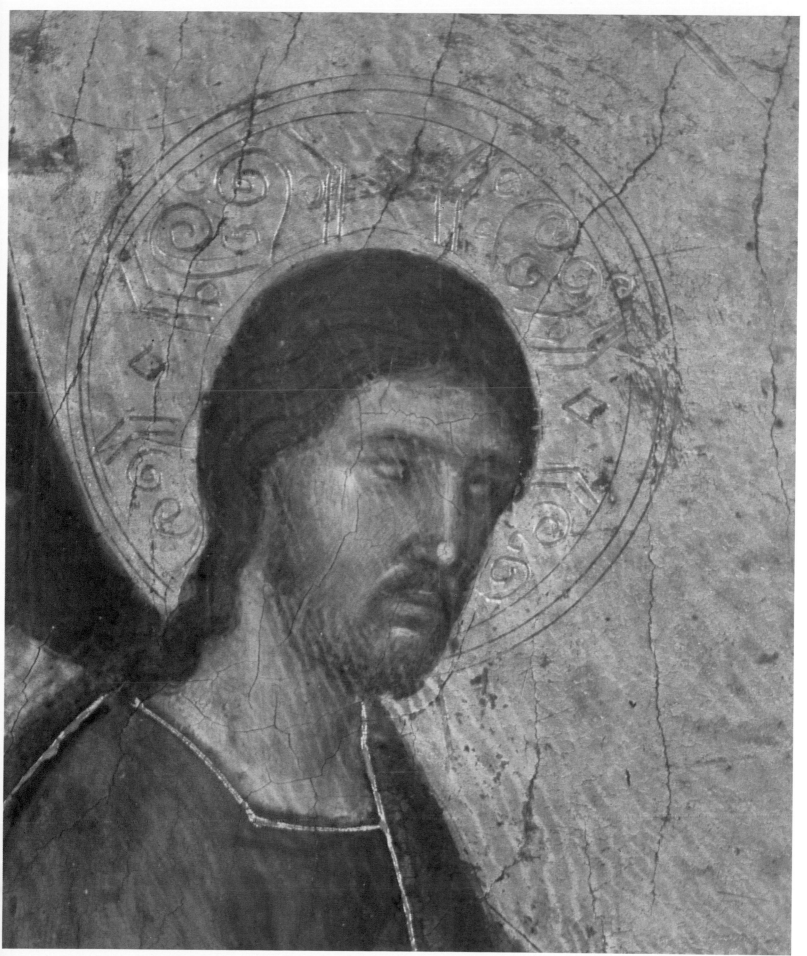

DUCCIO, *THE CALLING OF THE APOSTLES PETER AND ANDREW*

And Jesus went about all Galilee, teaching in their synagogues, and preaching the gospel of the kingdom, and healing all manner of sickness and all manner of disease among the people. MATTHEW 5:23

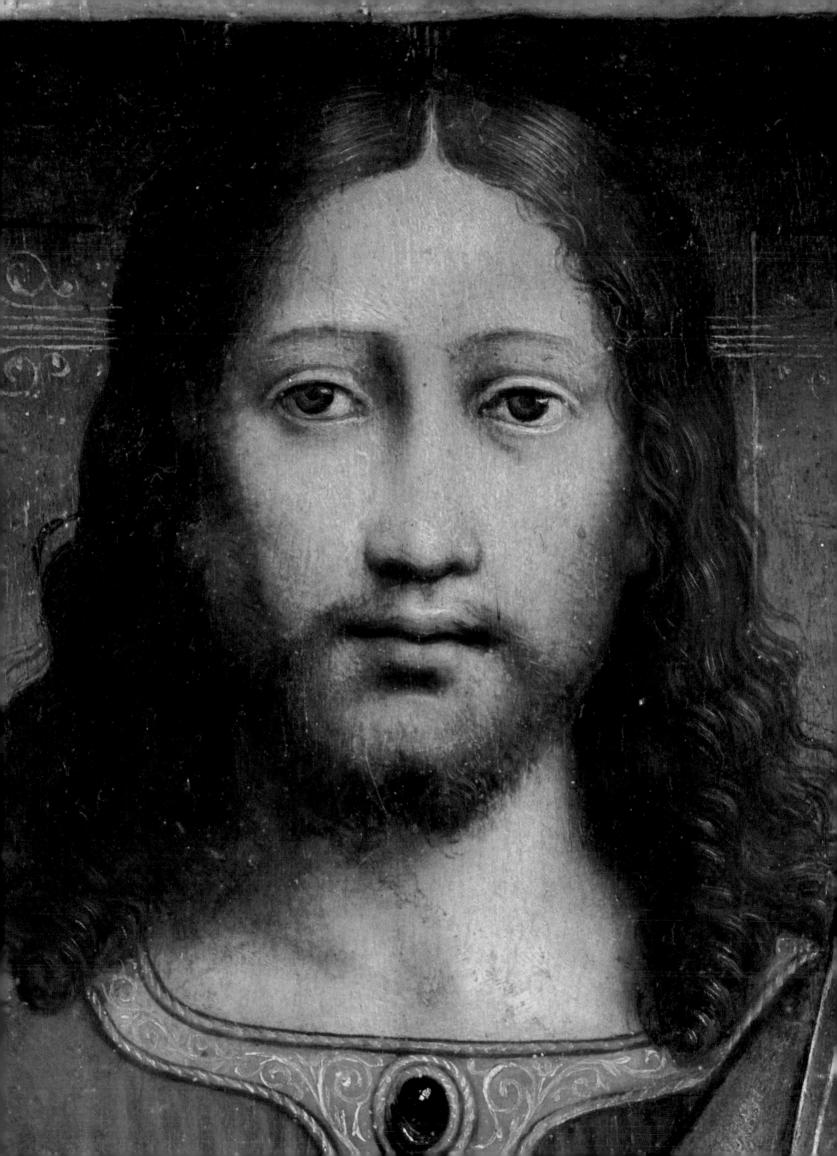

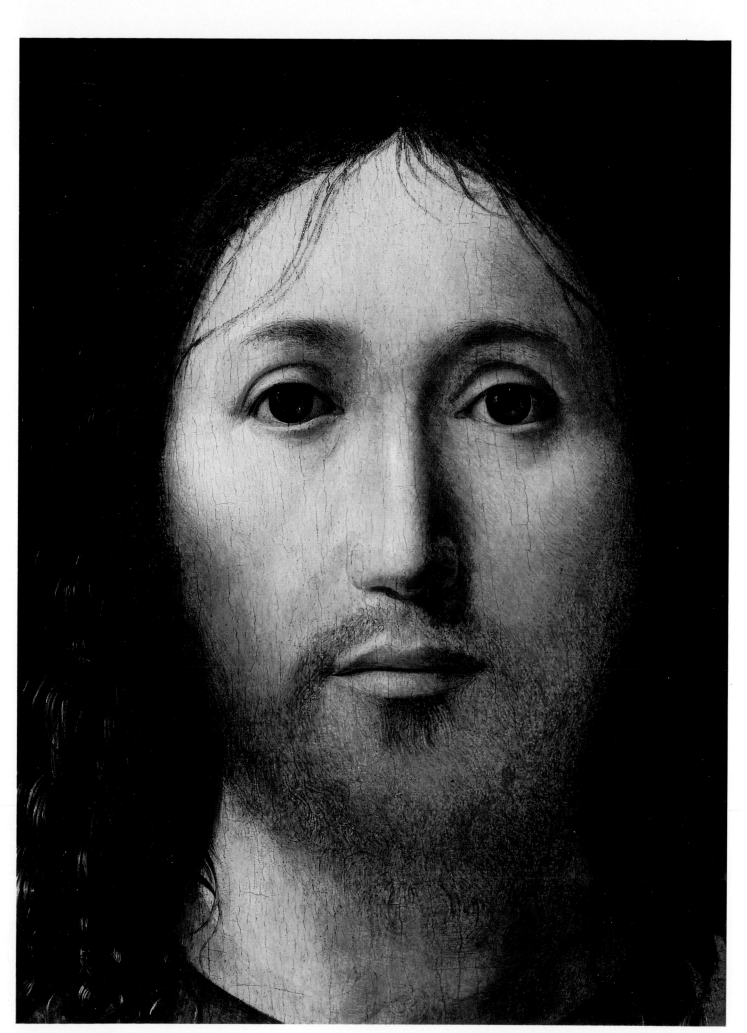

ANTONELLA DA MESSINA, *SALVATOR MUNDI*

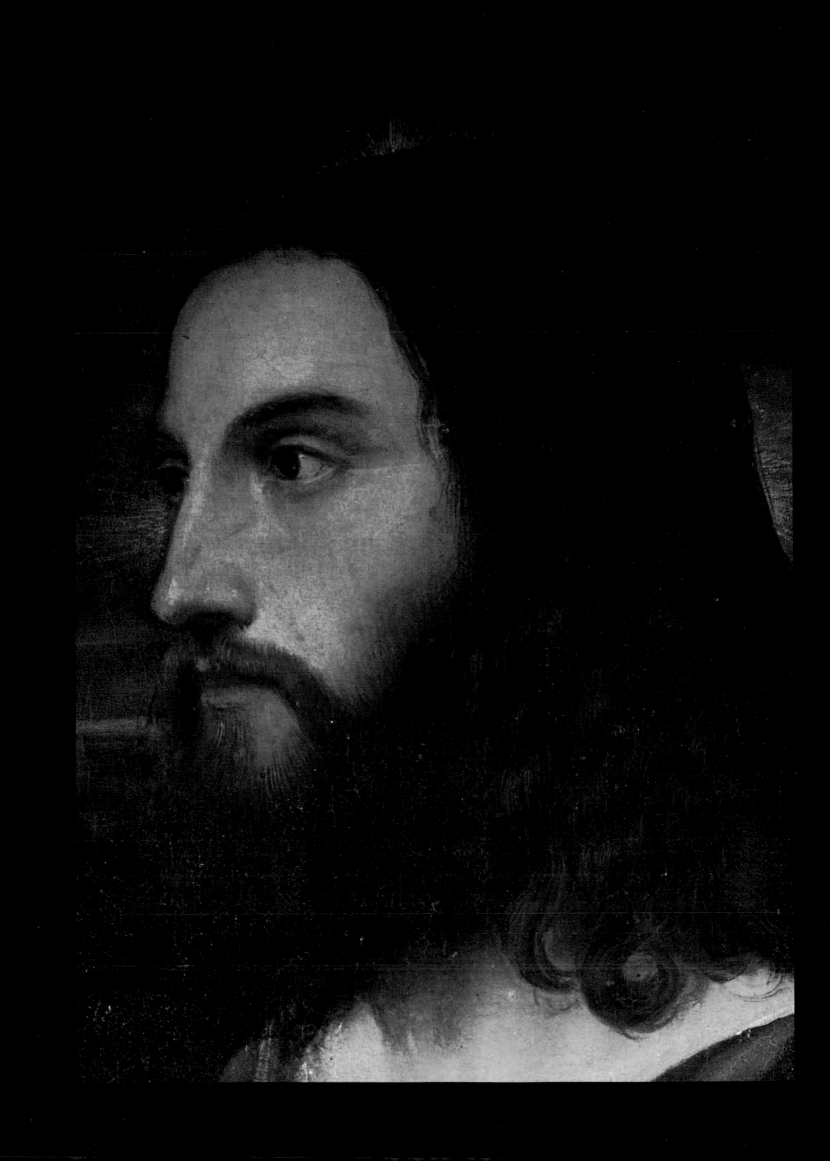

*A*nd seeing the multitudes, he went up into a mountain:
and when he was set, his disciples came unto him:
And he opened his mouth, and taught them, saying,

BLESSED ARE THE POOR IN SPIRIT: FOR THEIRS IS THE KINGDOM OF HEAVEN.

BLESSED ARE THEY THAT MOURN: FOR THEY SHALL BE COMFORTED.

BLESSED ARE THE MEEK: FOR THEY SHALL INHERIT THE EARTH.

BLESSED ARE THEY WHICH DO HUNGER AND THIRST AFTER RIGHTEOUSNESS: FOR THEY
SHALL BE FILLED.

BLESSED ARE THE MERCIFUL: FOR THEY SHALL OBTAIN MERCY.

BLESSED ARE THE PURE IN HEART: FOR THEY SHALL SEE GOD.

BLESSED ARE THE PEACEMAKERS: FOR THEY SHALL BE CALLED THE CHILDREN OF GOD.

BLESSED ARE THEY WHICH ARE PERSECUTED FOR RIGHTEOUSNESS' SAKE:
FOR THEIRS IS THE KINGDOM OF HEAVEN.

BLESSED ARE YE, WHEN MEN SHALL REVILE YOU, AND PERSECUTE YOU, AND
SHALL SAY ALL MANNER OF EVIL AGAINST YOU FALSELY, FOR MY SAKE.

REJOICE, AND BE EXCEEDING GLAD: FOR GREAT IS YOUR REWARD IN HEAVEN: FOR SO
PERSECUTED THEY THE PROPHETS WHICH WERE BEFORE YOU. MATTHEW 5:2–13

TITIAN, *HEAD OF CHRIST*

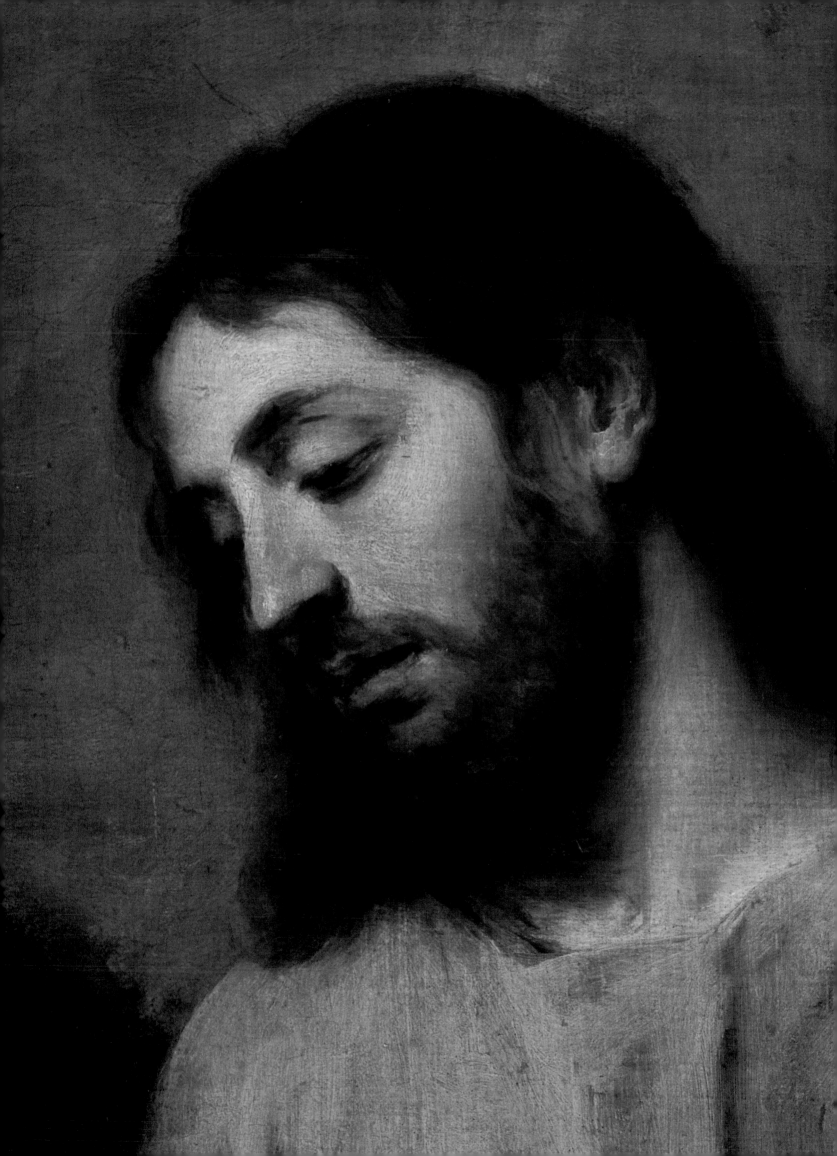

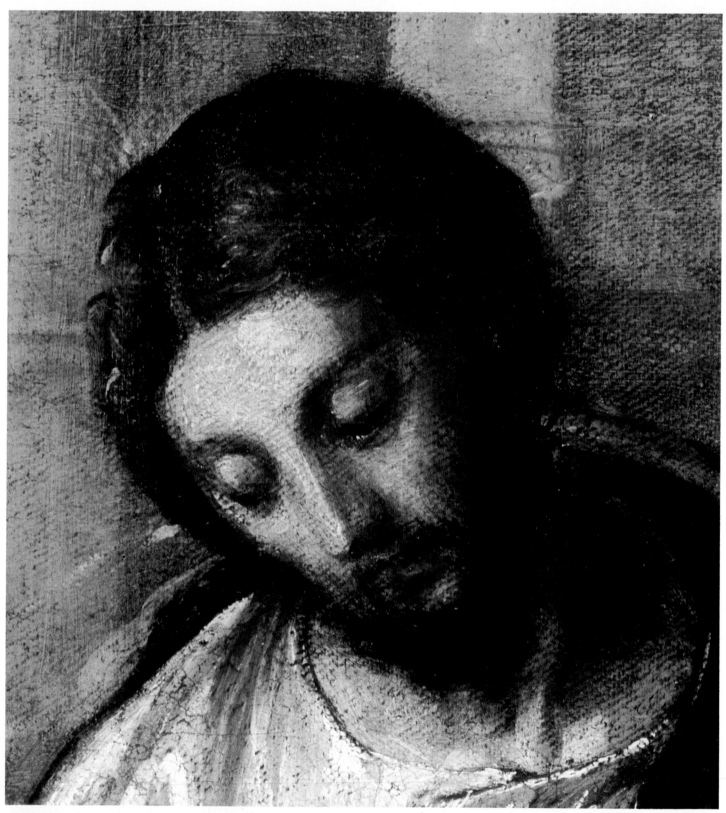

EL GRECO, *THE MIRACLE OF CHRIST HEALING THE BLIND*

VERILY, VERILY, I SAY UNTO YOU, THE HOUR IS COMING, AND NOW IS, WHEN THE DEAD SHALL HEAR THE VOICE OF THE SON OF GOD: AND THEY THAT HEAR SHALL LIVE. JOHN 5:25

FOR JUDGMENT I AM COME INTO THIS WORLD, THAT THEY WHICH SEE NOT MIGHT SEE; AND THAT THEY WHICH SEE MIGHT BE MADE BLIND. JOHN 9:39

BARTOLOMÉ ESTEBÁN MURILLO, *CHRIST HEALING THE PARALYTIC AT THE POOL OF BETHESDA*

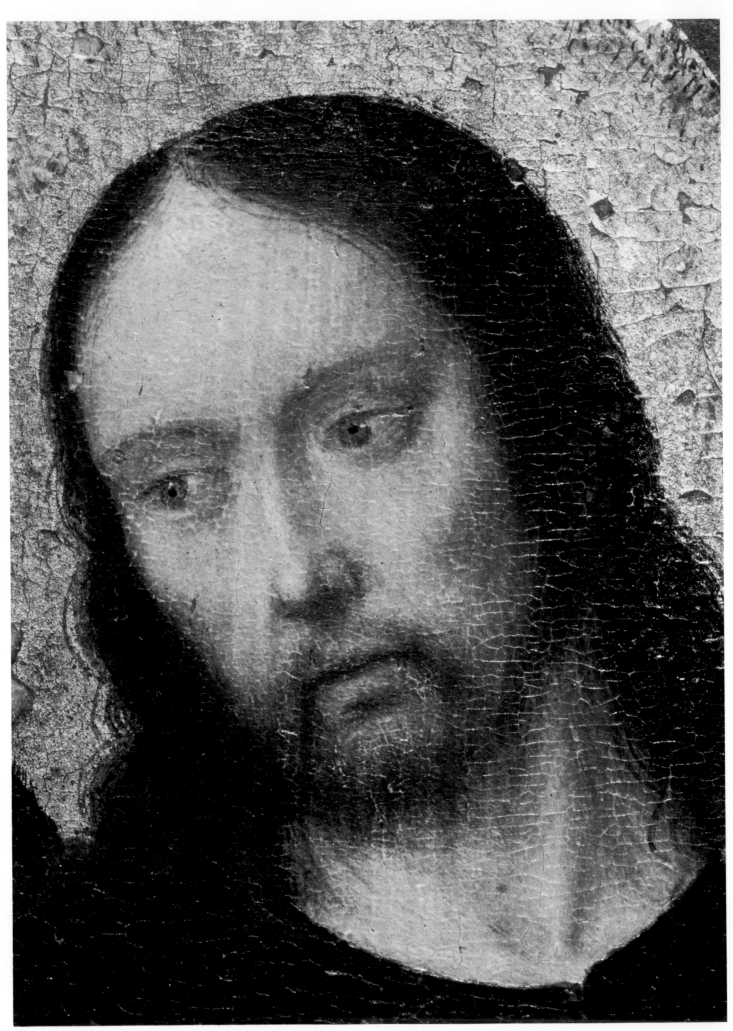

GERARD DAVID, *CHRIST TAKING LEAVE OF HIS MOTHER*

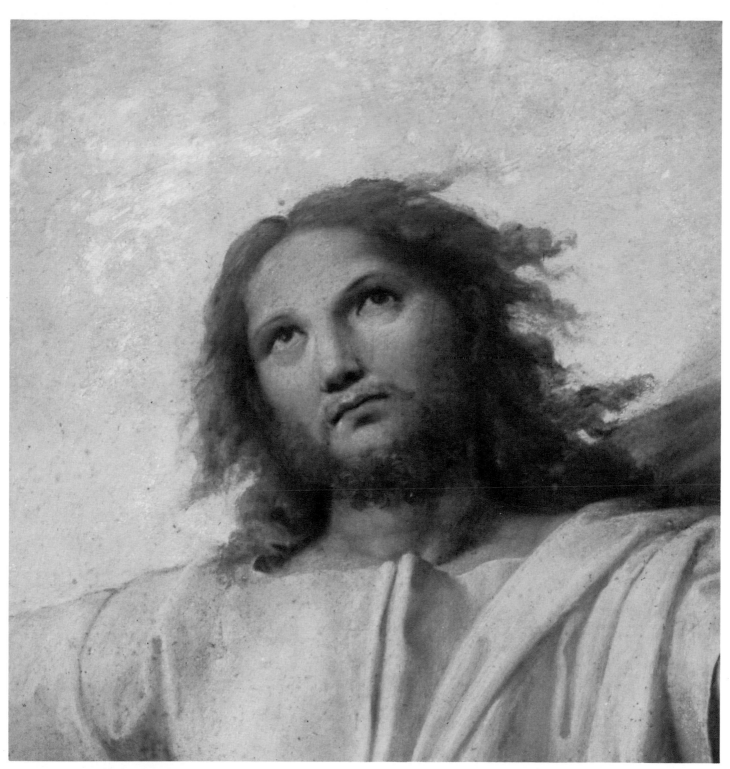

RAPHAEL, *THE TRANSFIGURATION*

*A*nd after six days Jesus taketh Peter, James, and John his brother, and bringth them up into an high mountain apart, and was transfigured before them: and his face did shine as the sun, and his raiment was white as the light. MATTHEW 17:1–2

VERILY I SAY UNTO YOU, EXCEPT YE BE CONVERTED, AND BECOME AS LITTLE CHILDREN, YE SHALL NOT ENTER INTO THE KINGDOM OF HEAVEN. WHOSOEVER THEREFORE SHALL HUMBLE HIMSELF AS THIS LITTLE CHILD, THE SAME IS GREATEST IN THE KINGDOM OF HEAVEN. AND WHOSO SHALL RECEIVE ONE SUCH LITTLE CHILD IN MY NAME RECEIVETH ME. MATTHEW 18:2–5

NICOLAES MAES, *CHRIST BLESSING THE CHILDREN*

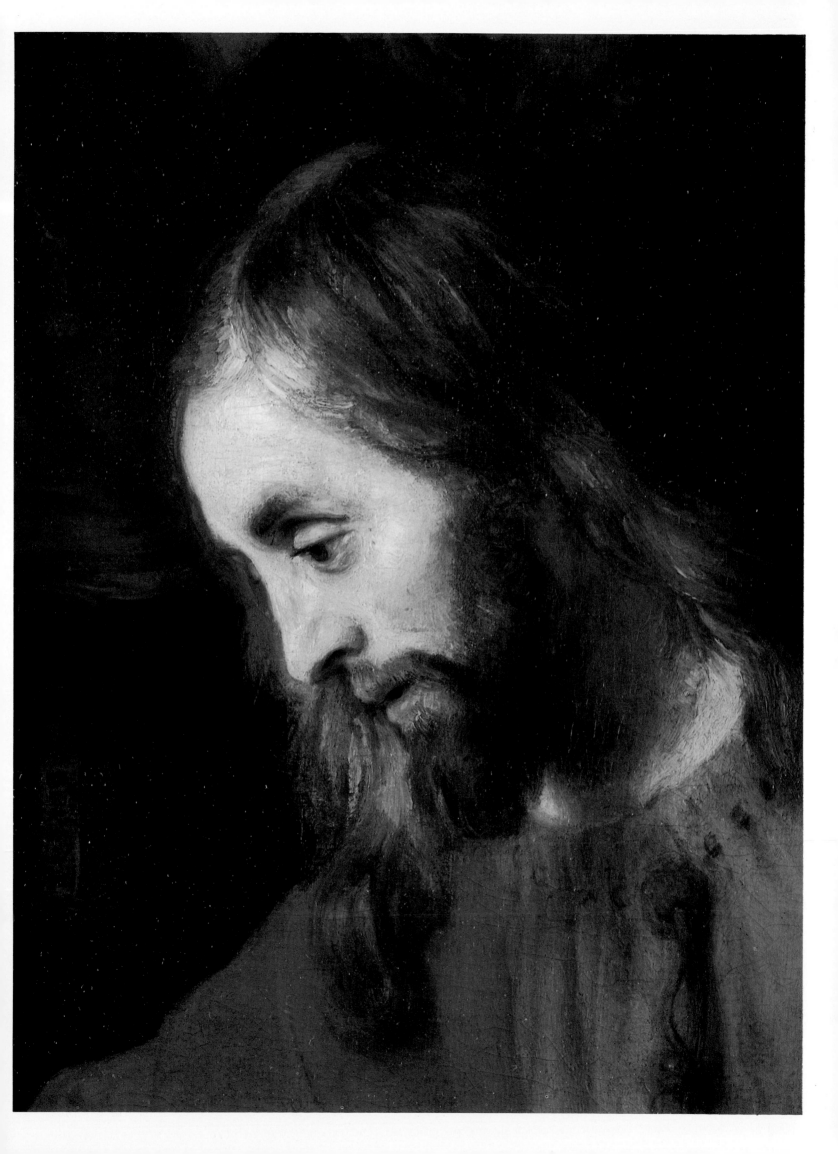

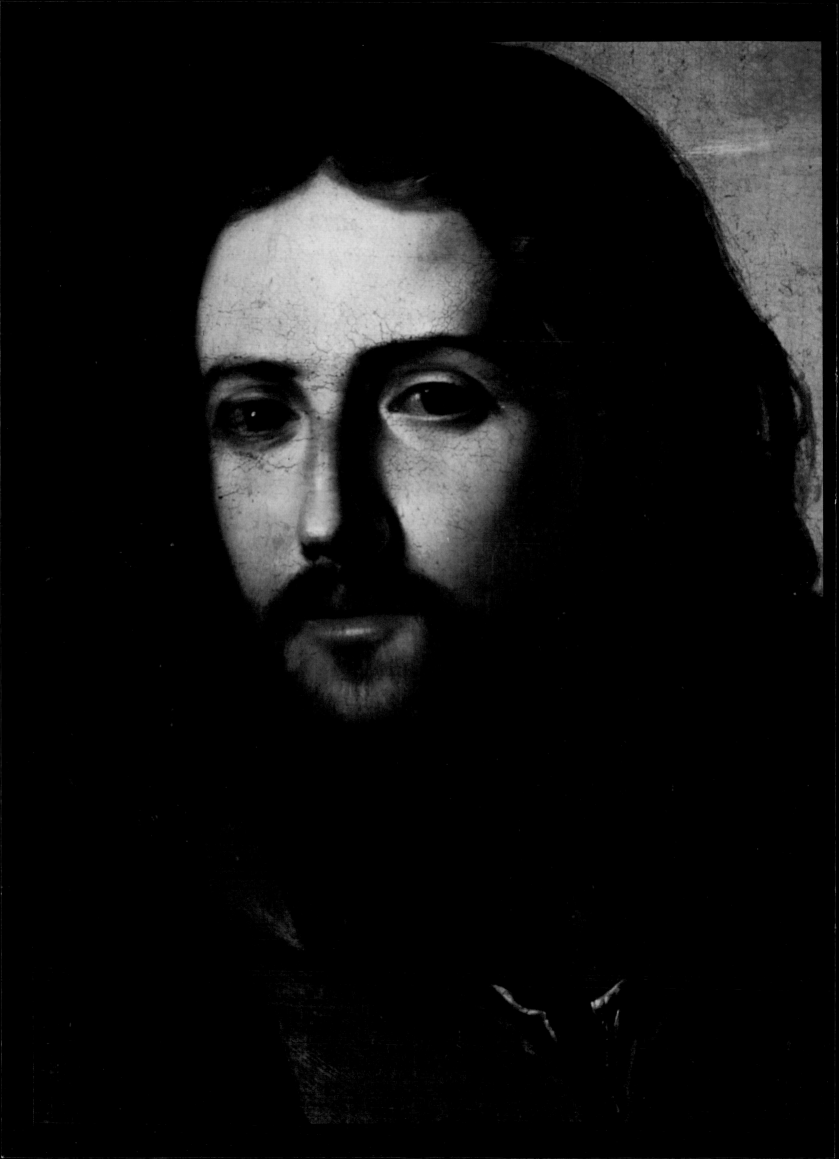

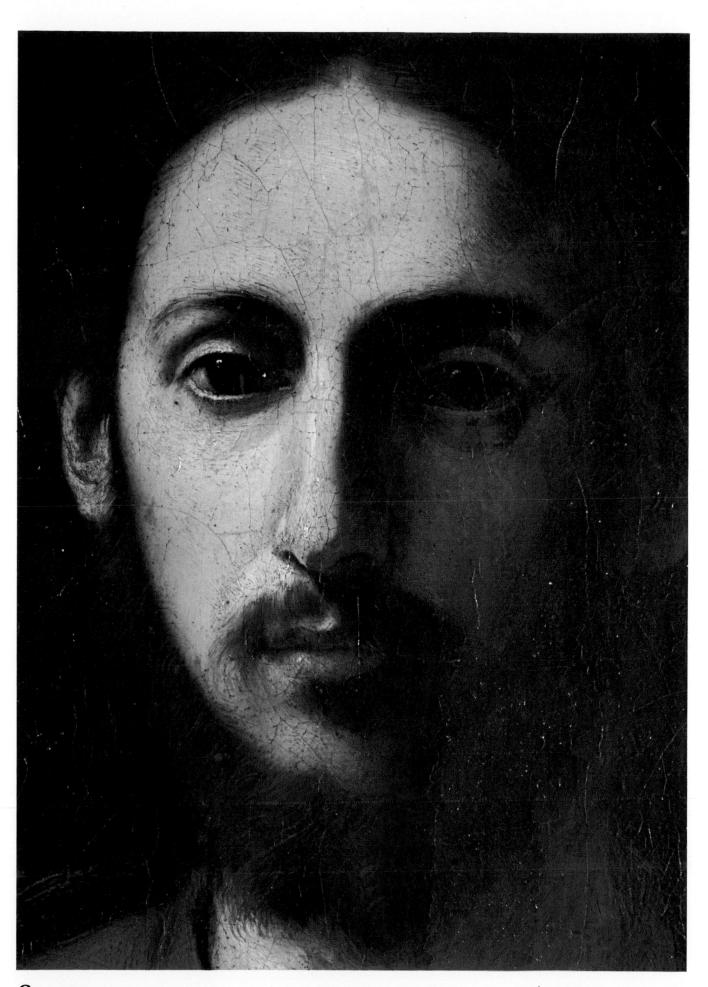

JOSÉ DE RIBERA, *THE SAVIOR*

SUFFER LITTLE CHILDREN, AND FORBID THEM NOT, TO COME UNTO ME: FOR OF SUCH IS THE KINGDOM OF HEAVEN. MATTHEW 19:14

PACECCO DE ROSA, *CHRIST BLESSING THE CHILDREN*

IT IS WRITTEN, MY HOUSE SHALL BE CALLED THE HOUSE OF PRAYER: BUT YE HAVE MADE IT A DEN OF THIEVES.

MATTHEW 21:13

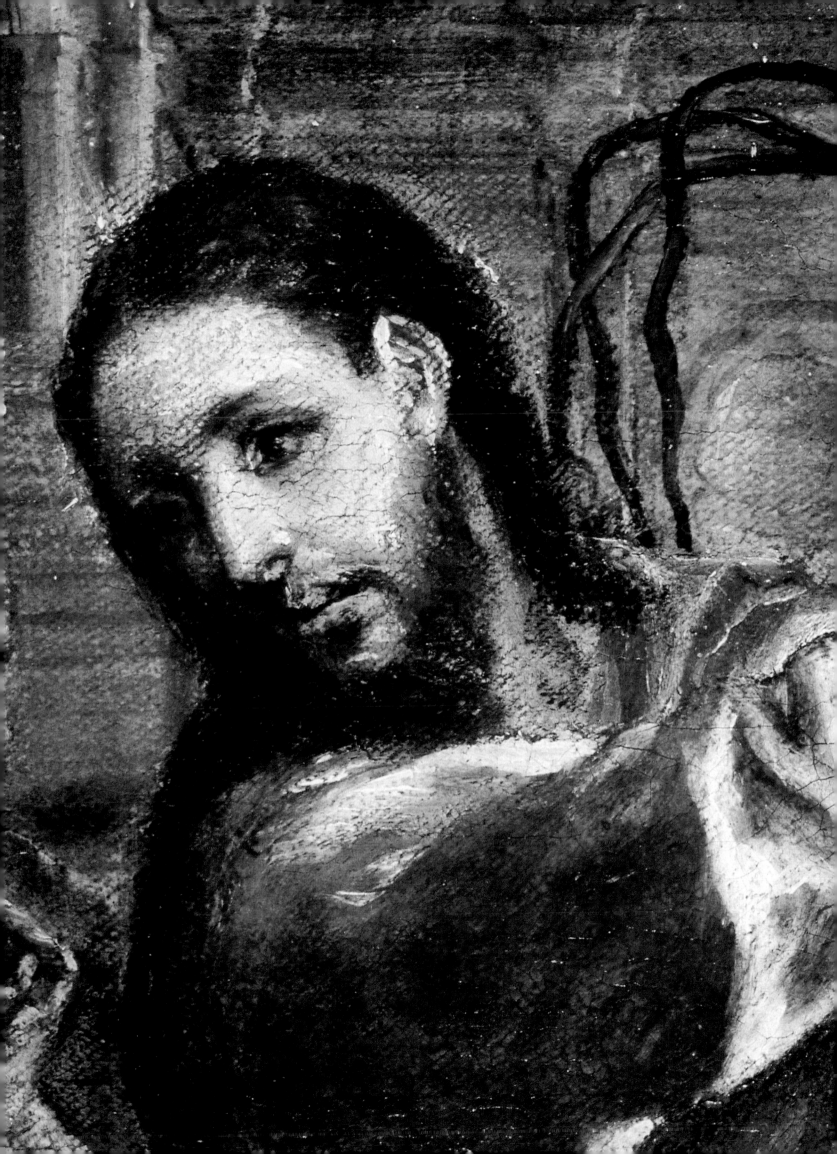

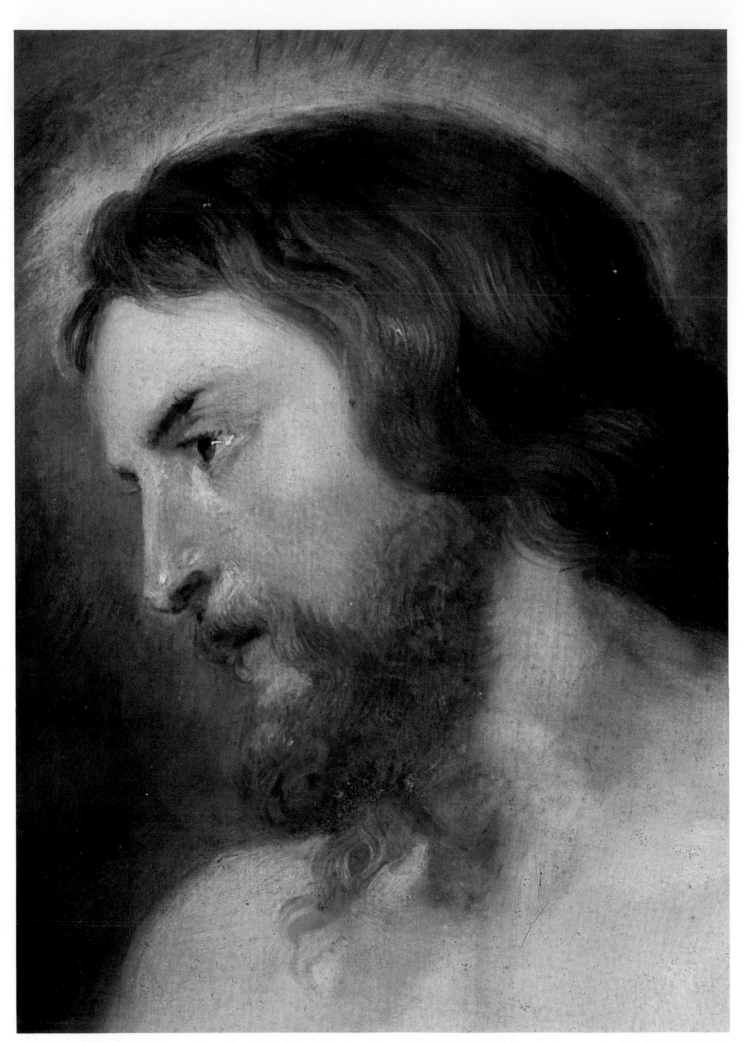

PETER PAUL RUBENS, *CHRIST AND MARY MAGDALEN*

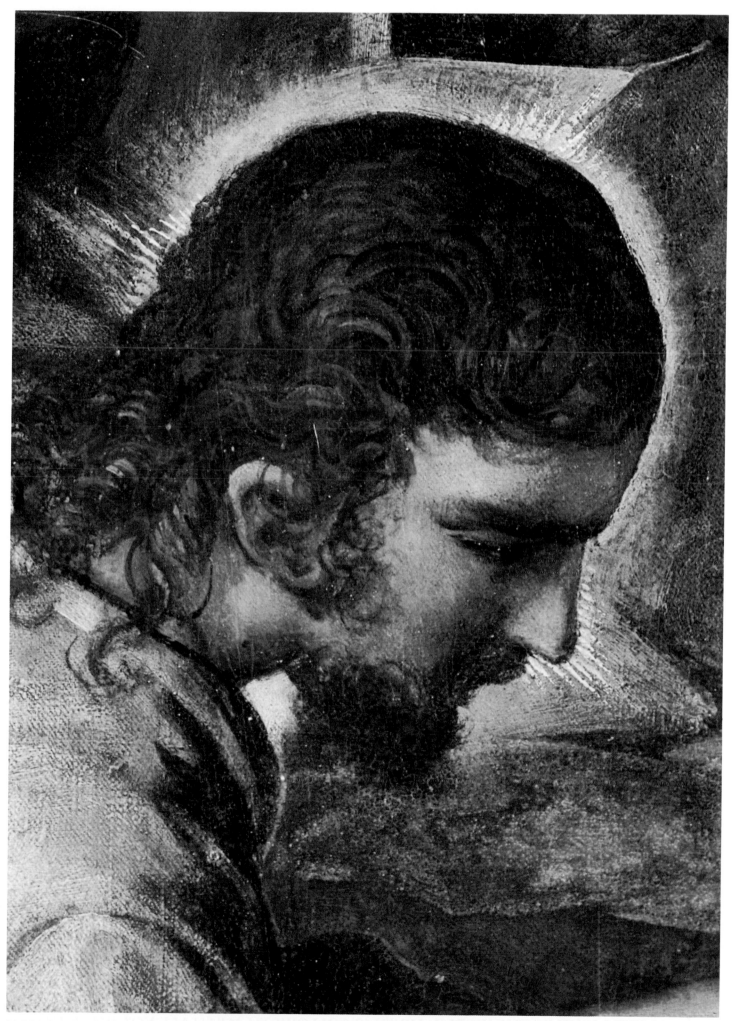

JACOPO ROBUSTI TINTORETTO, *CHRIST AT THE HOME OF MARY AND MARTHA*

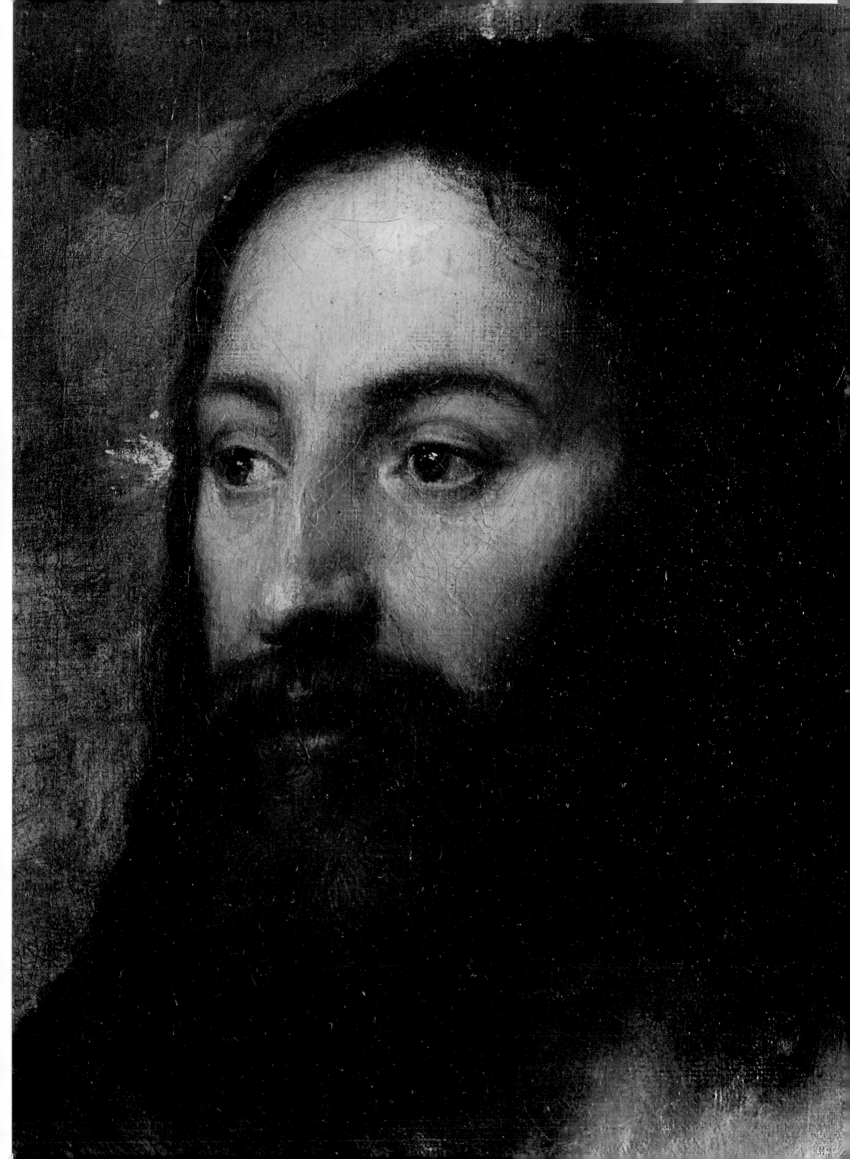

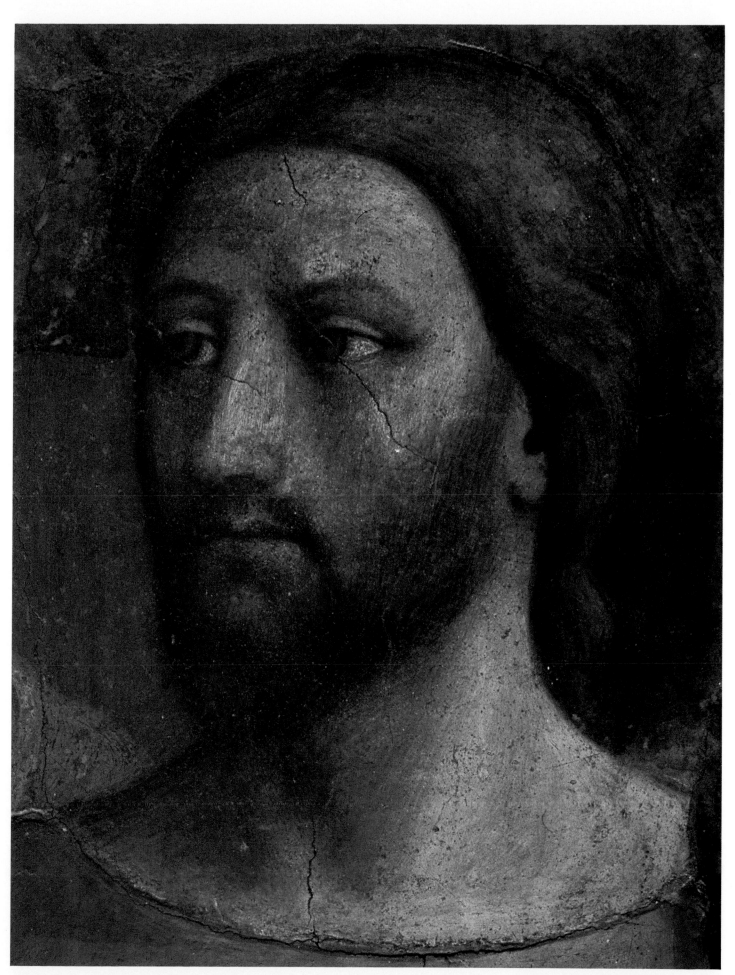

MASACCIO, *THE TRIBUTE MONEY*

RENDER THEREFORE UNTO CAESAR THE THINGS WHICH ARE CAESAR'S; AND UNTO GOD THE THINGS THAT ARE GOD'S. MATTHEW 23:21

TITIAN, *THE TRIBUTE MONEY*

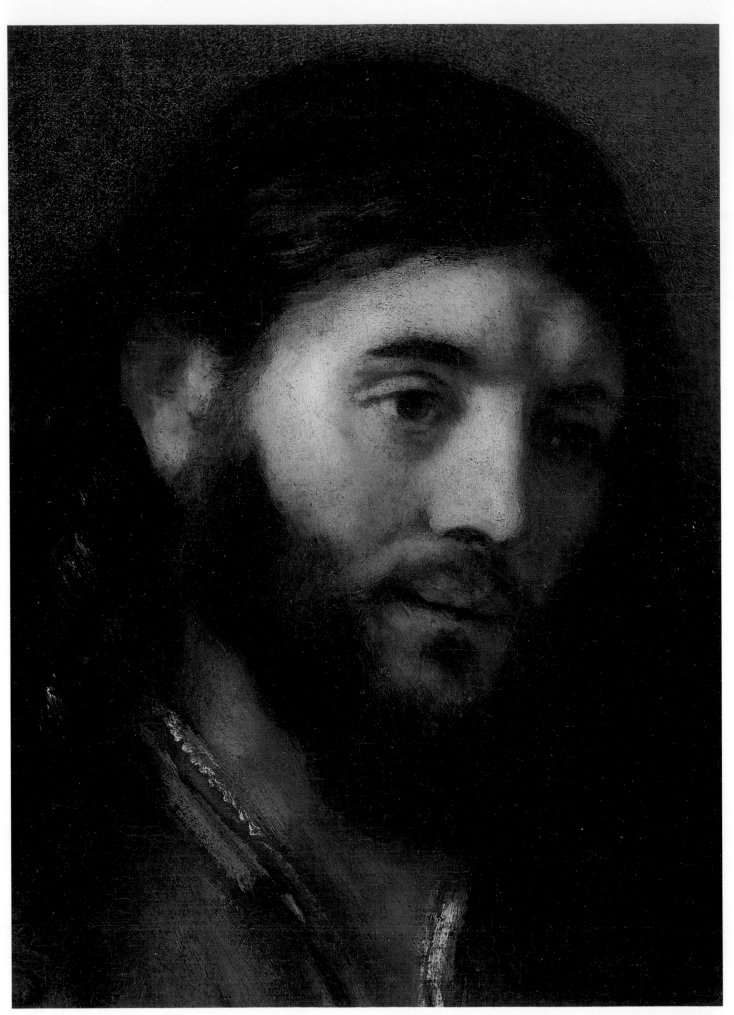

ATTRIBUTED TO REMBRANDT VAN RYN, *HEAD OF CHRIST*

I AM THE GOOD SHEPHERD, AND KNOW MY SHEEP, AND AM KNOWN OF MINE. AS THE FATHER KNOWETH ME, EVEN SO I KNOW THE FATHER: AND I LAY DOWN MY LIFE FOR THE SHEEP. JOHN 10:14–15

HIS SUFFERING

And as they did eat, Jesus took bread, and blessed, and brake it, and gave to them, and said, TAKE, EAT: THIS IS MY BODY. And he took the cup, and when he had given thanks, he gave it to them: and they all drank of it. And he said unto them, THIS IS MY BLOOD OF THE NEW TESTAMENT, WHICH IS SHED FOR MANY. MARK 14:22–24

SALVADOR DALI, *THE SACRAMENT OF THE LAST SUPPER*

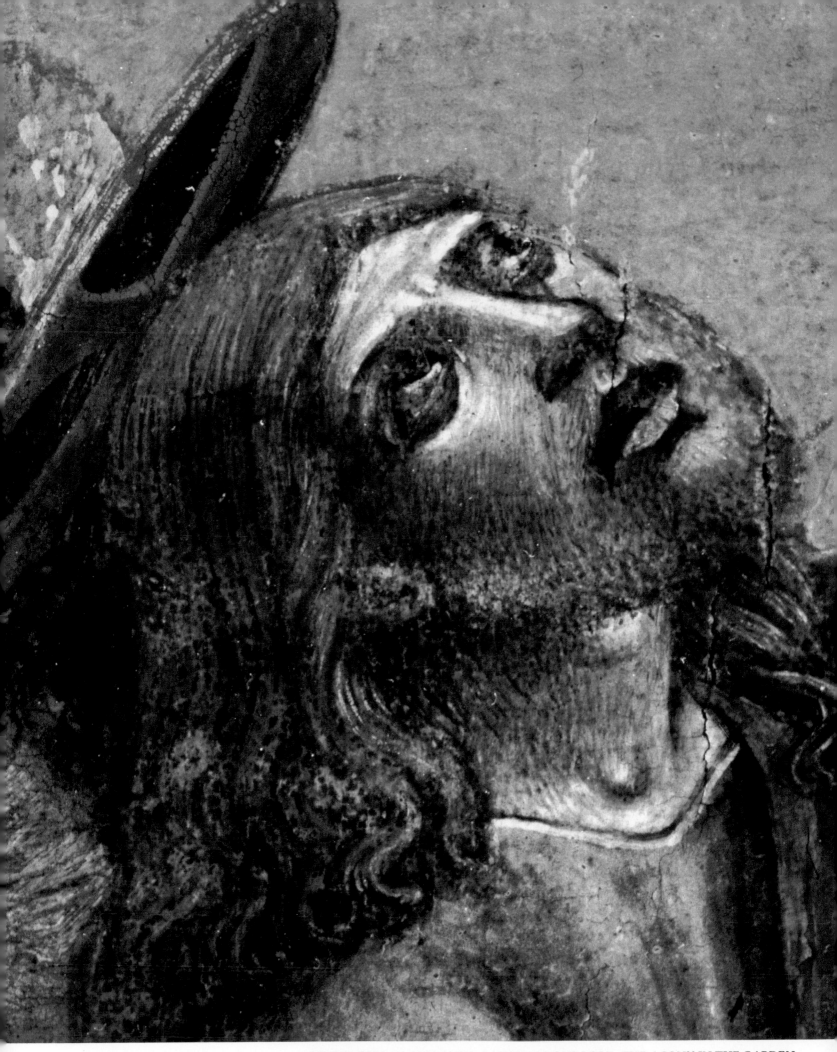

BENVENUTO DI GIOVANNI, *PASSION OF OUR LORD: THE AGONY IN THE GARDEN*

FATHER, IF THOU BE WILLING, REMOVE THIS CUP FROM ME:
NEVERTHELESS NOT MY WILL, BUT THINE, BE DONE. LUKE 22:42

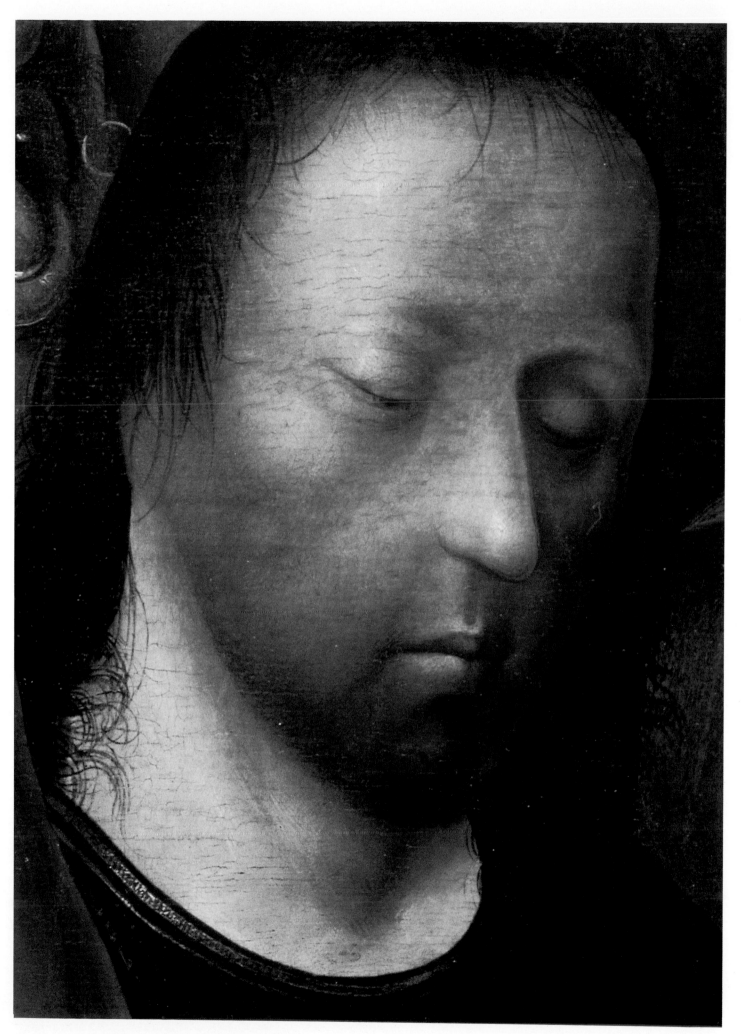

HIERONYMUS BOSCH, *CHRIST BEFORE PILATE*

And when they had bound him, they led him away, and delivered him to Pontius Pilate the governor. MATTHEW 27:2

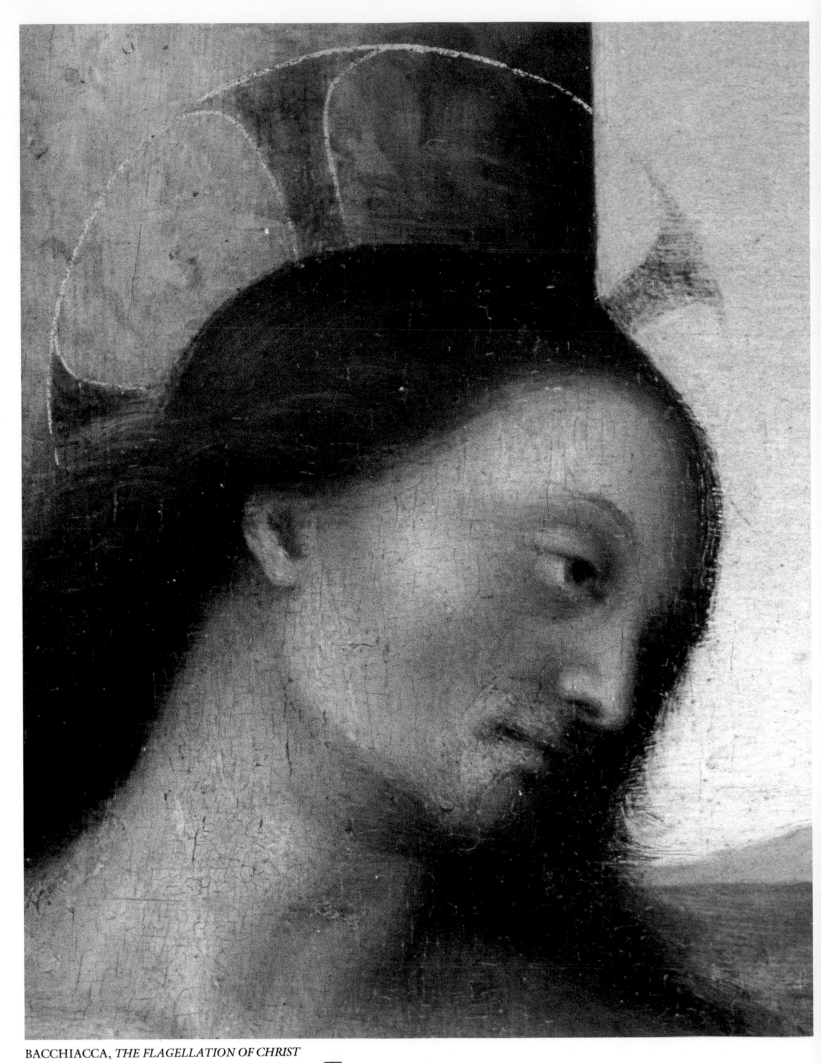

BACCHIACCA, *THE FLAGELLATION OF CHRIST*

Then Pilate therefore took Jesus, and scourged him. JOHN 19:1

DIEGO RODRIGUEZ VELAZQUEZ, *CHRIST AFTER THE FLAGELLATION CONTEMPLATED BY THE CHRISTIAN SOUL*

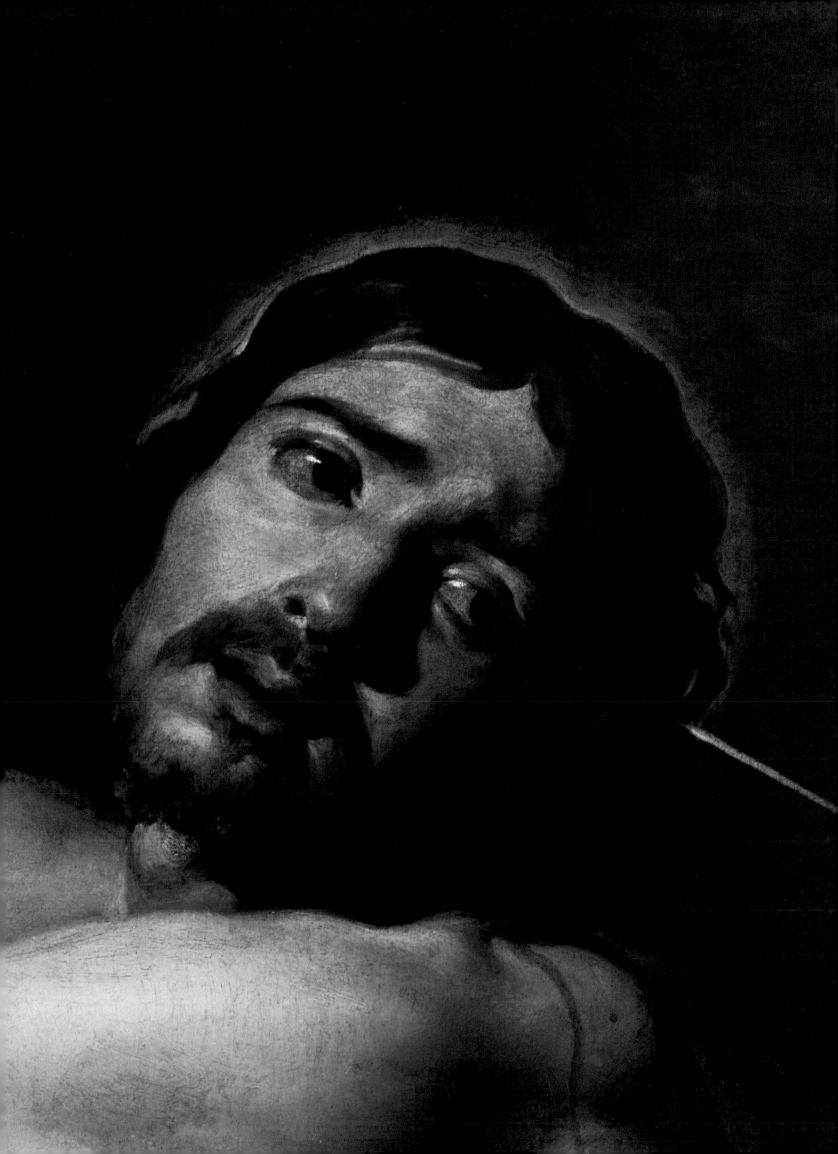

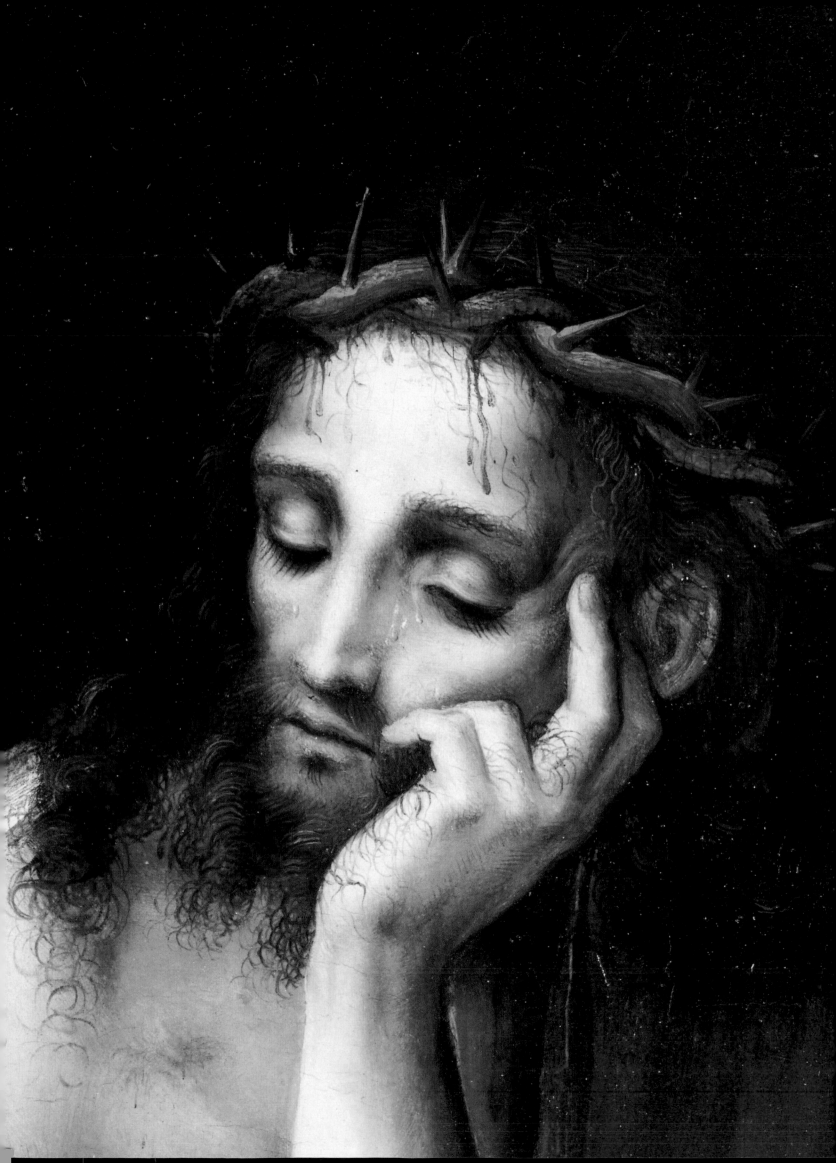

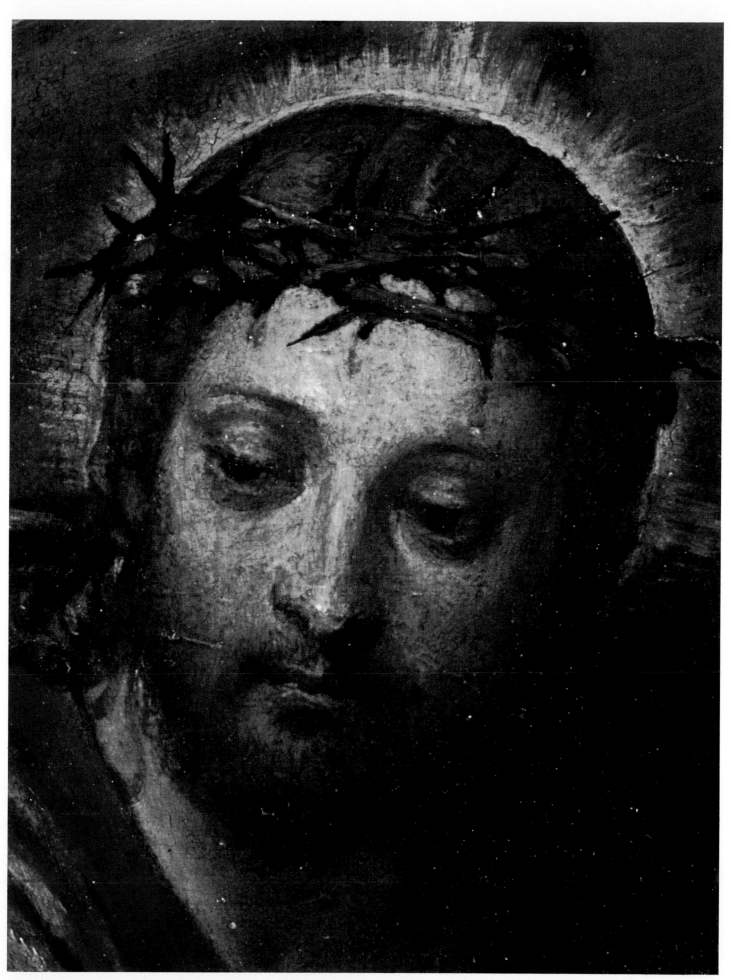

PAOLO VERONESE, *CARRYING THE CROSS*

And the soldiers platted a crown of thorns, and put it on his head, and they put on him a purple robe, and said, Hail, King of the Jews! JOHN 19:2–3

LUIS DE MORALES, *MAN OF SORROWS*

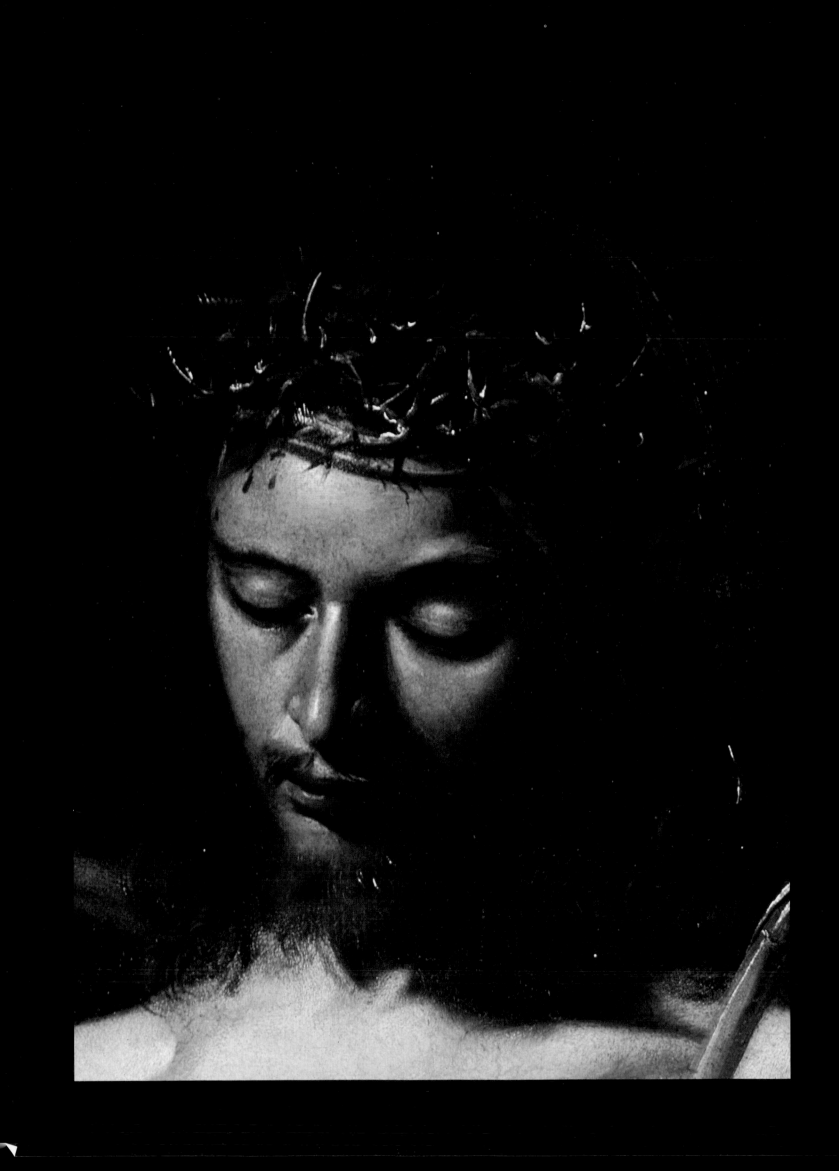

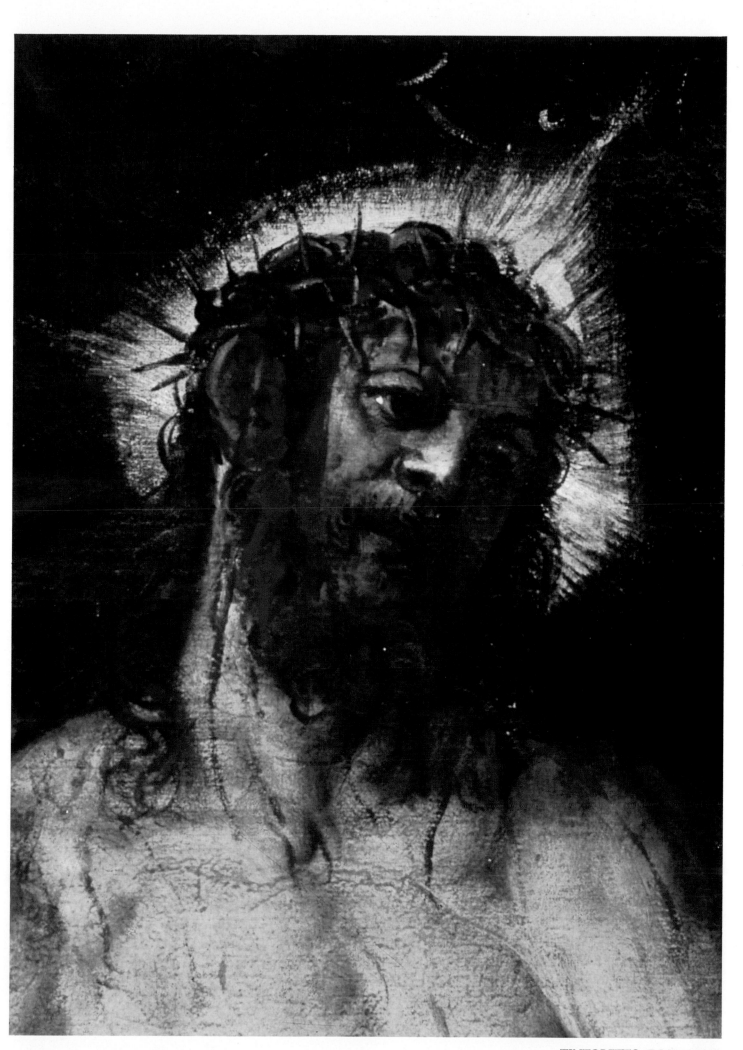

TINTORETTO, *ECCE HOMO*

MICHELANGELO CARAVAGGIO, *ECCE HOMO*

And they smote him on the head with a reed, and
did spit upon him, and bowing their knees worshipped
him. And when they had mocked him, they took off
the purple from him, and put his own clothes on him,
and led him out to crucify him. MARK 15:19–20

ANTHONY VAN DYCK, *THE MOCKING OF CHRIST*

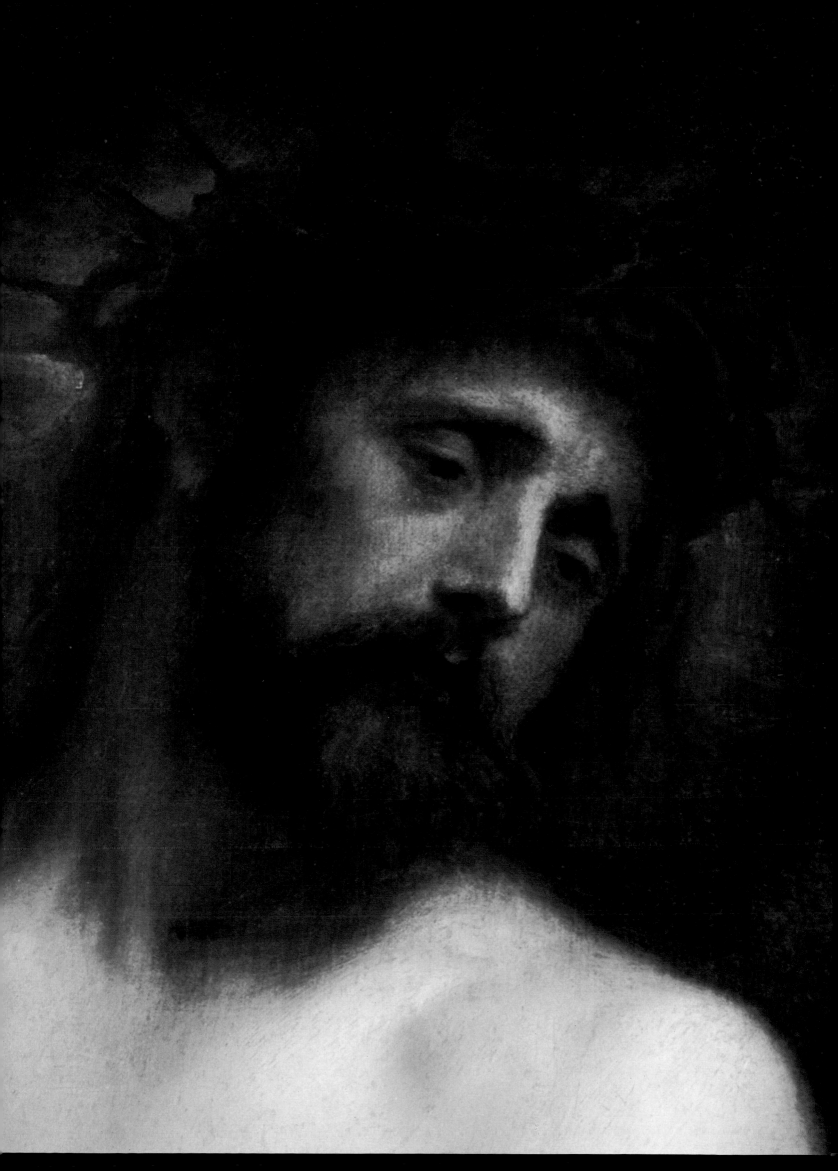

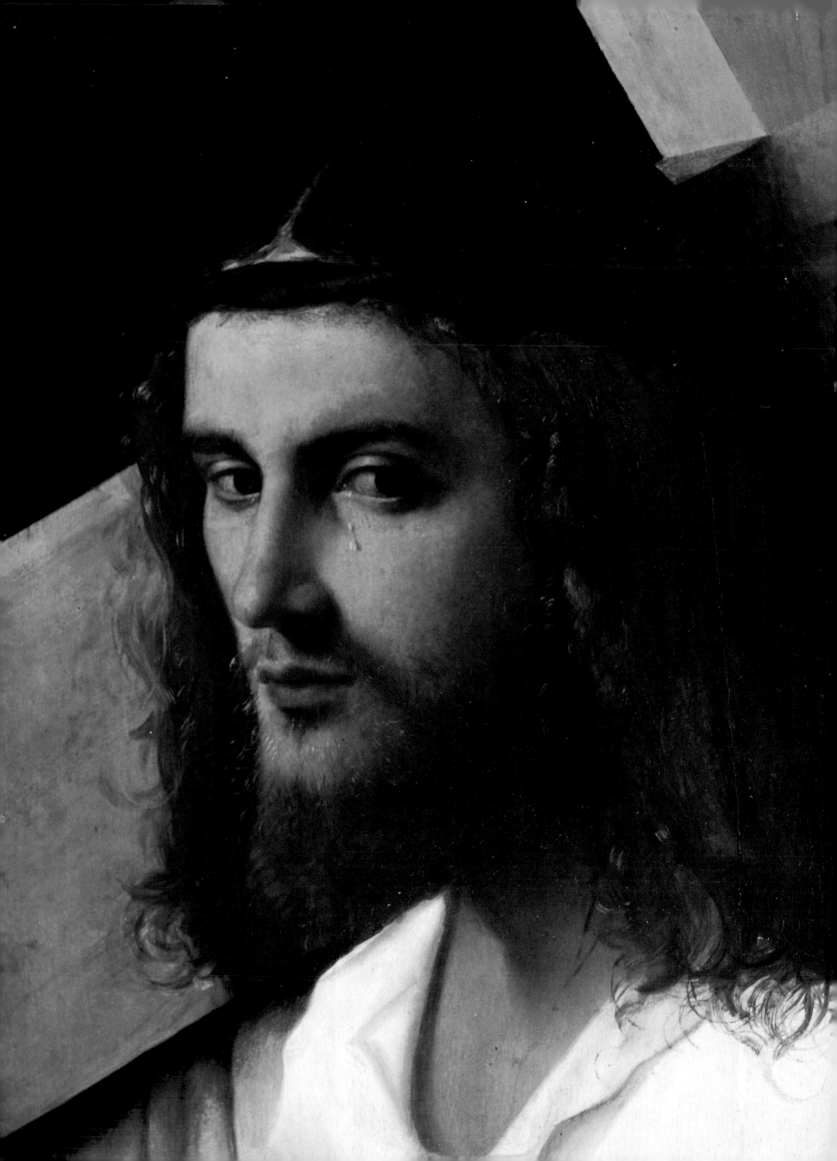

*A*nd there followed him a great company of people, and of women, which also bewailed and lamented him. LUKE 23:26–27

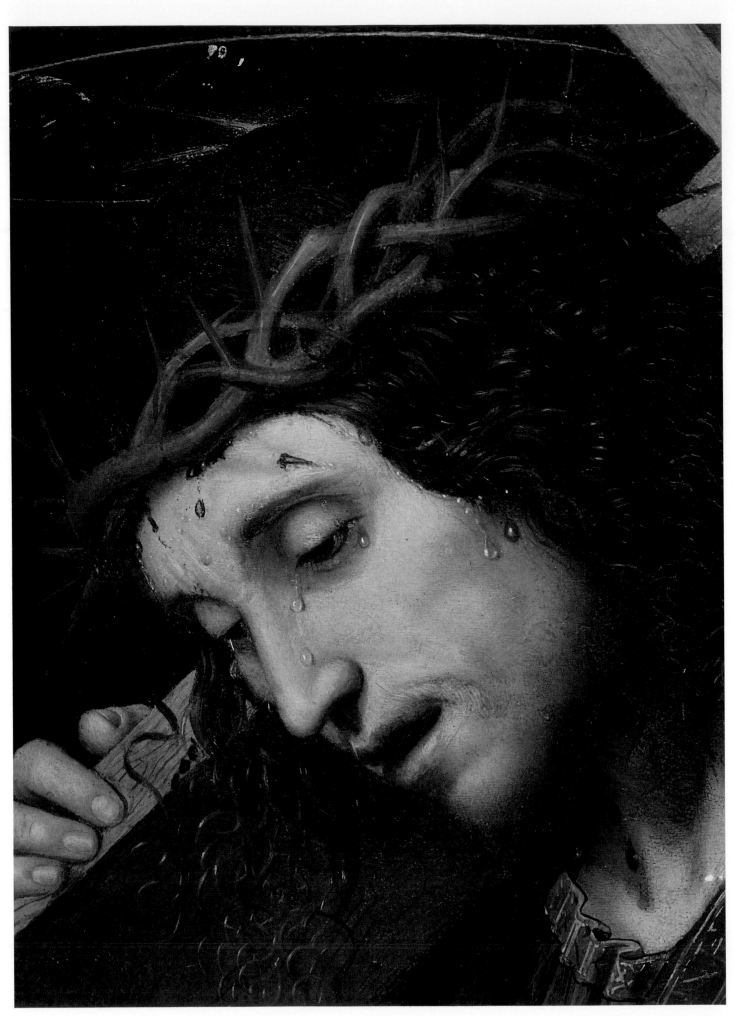

GIAN FRANCESCO DE MAINERI, *CHRIST CARRYING THE CROSS*

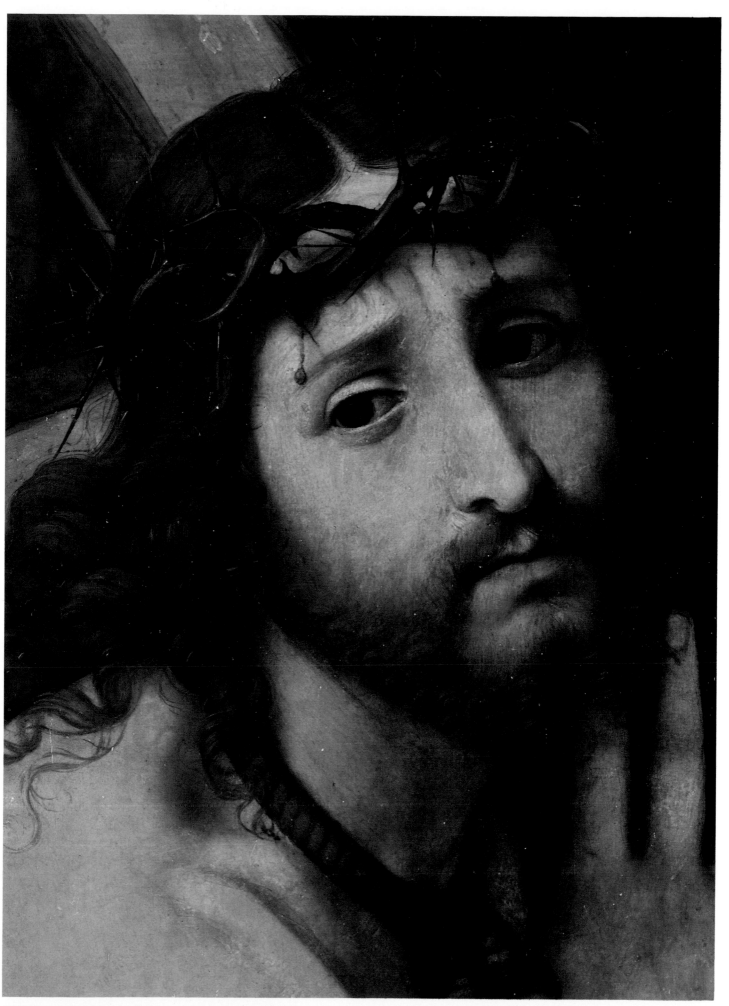

ANDREA SOLARIO, *CHRIST CARRYING THE CROSS*

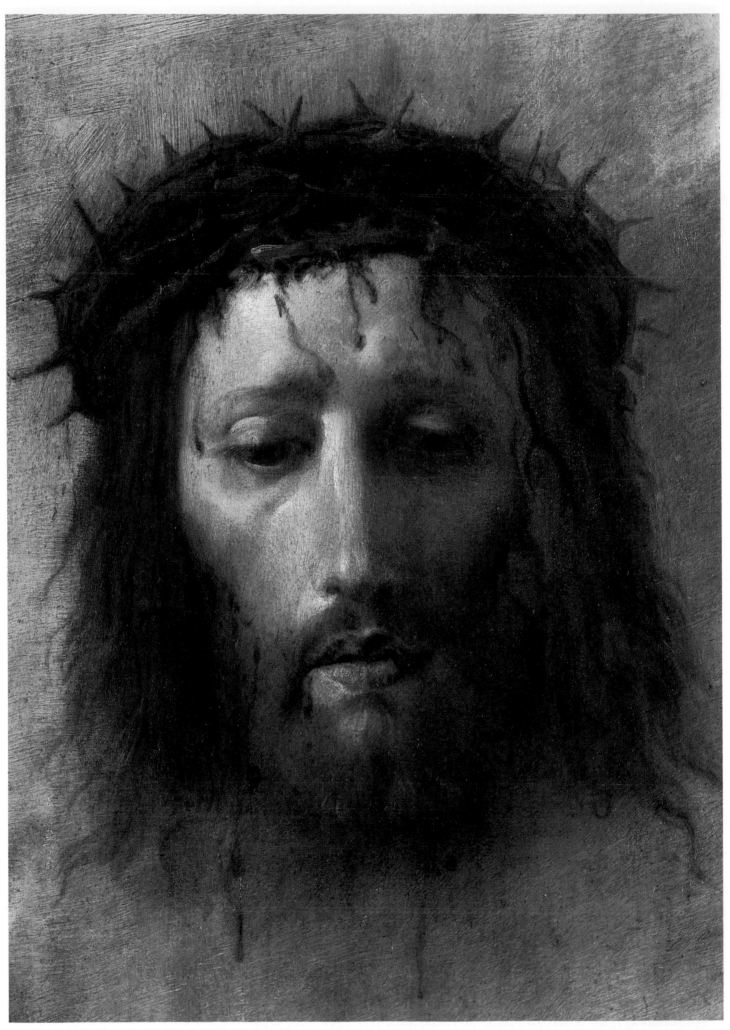

DOMENICO FETTI, *THE VEIL OF VERONICA*

GEORGES ROUAULT, *ECCE HOMO*

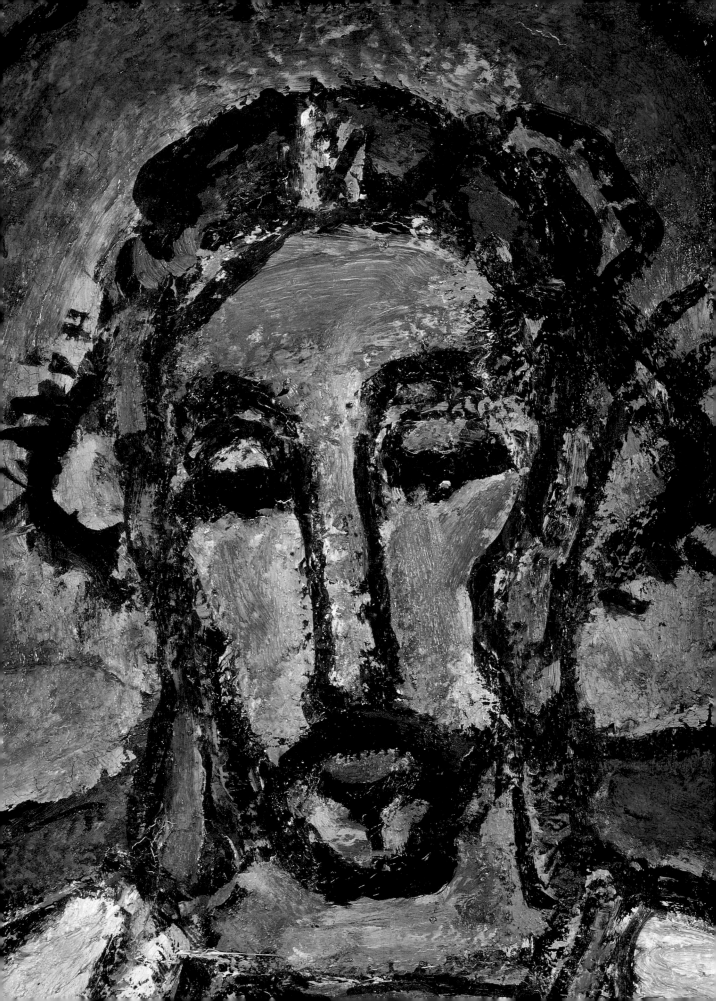

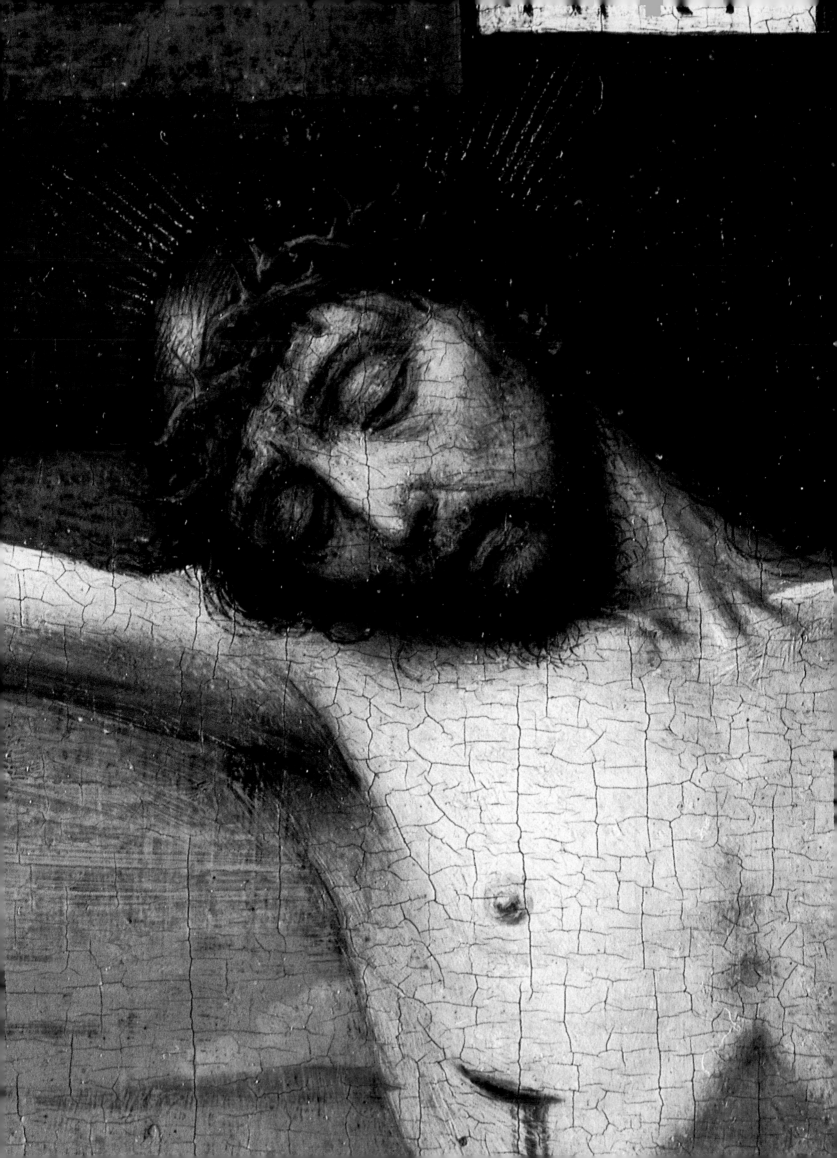

*A*nd they crucified him, and parted his garments, casting lots: that it might be fulfilled which was spoken by the prophet, They parted my garments among them, and upon my vesture did they cast lots. MATTHEW 27:35

*N*ow from the sixth hour there was darkness over all the land unto the ninth hour. MATTHEW 27:45

*A*nd when Jesus had cried with a loud voice, he said, FATHER, INTO THY HANDS I COMMEND MY SPIRIT: and having said thus, he gave up the ghost. LUKE 23:46

PESELLINO, *THE CRUCIFIXION WITH ST. JEROME AND ST. FRANCIS*

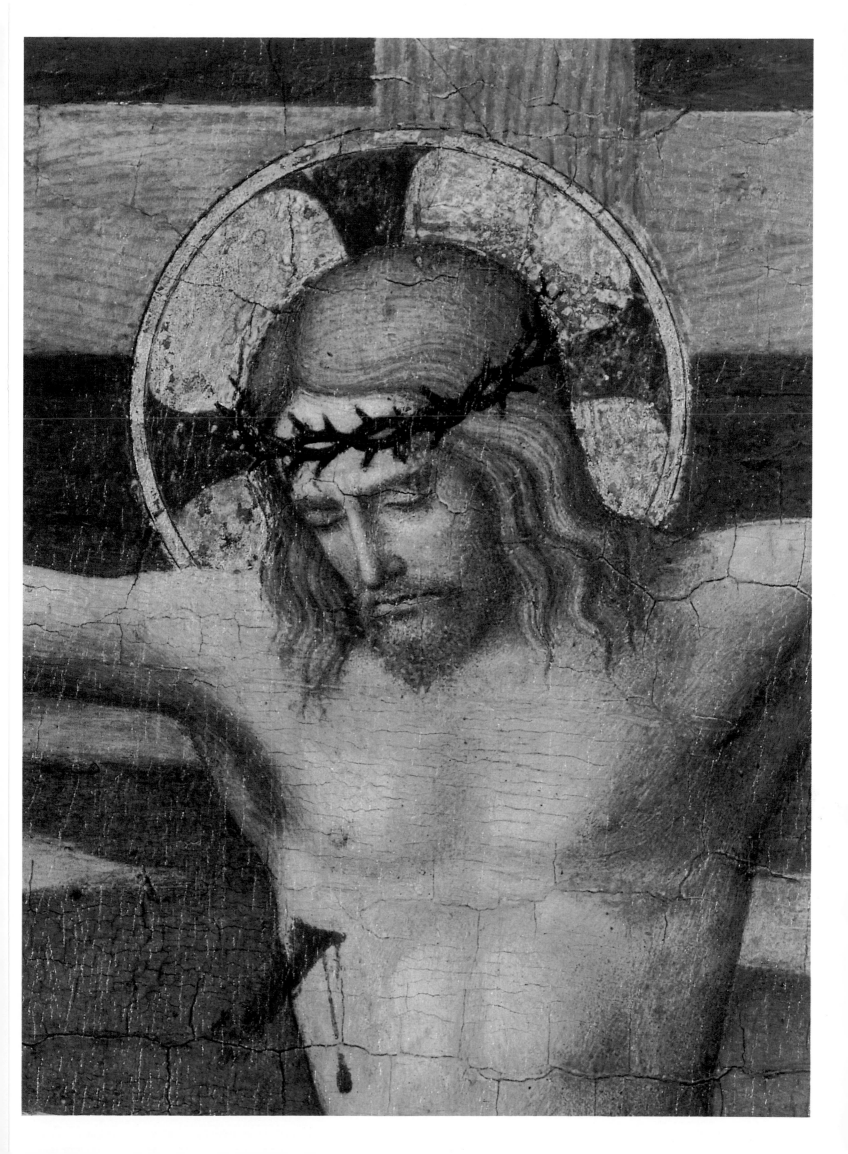

*A*nd, behold, the veil of the temple was rent in twain from the top to the bottom; and the earth did quake, and the rocks rent. And the graves were opened; and many bodies of the saints which slept arose, and came out of the graves after his resurrection, and went into the holy city, and appeared unto many. MATTHEW 27:51–53

CARLO CRIVELLI, *PIETA*

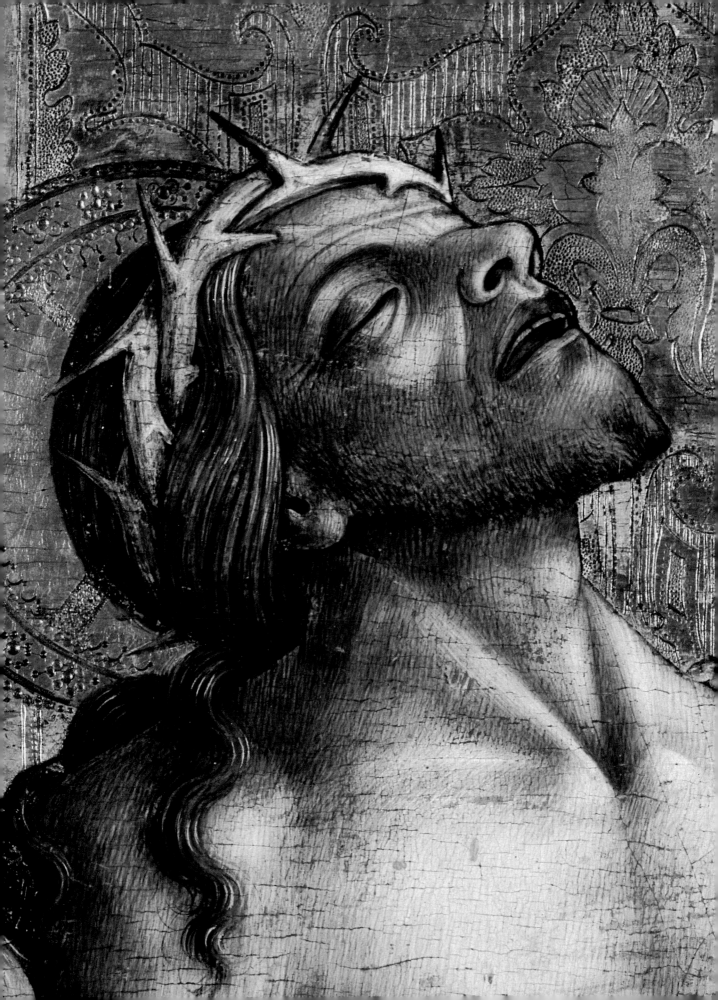

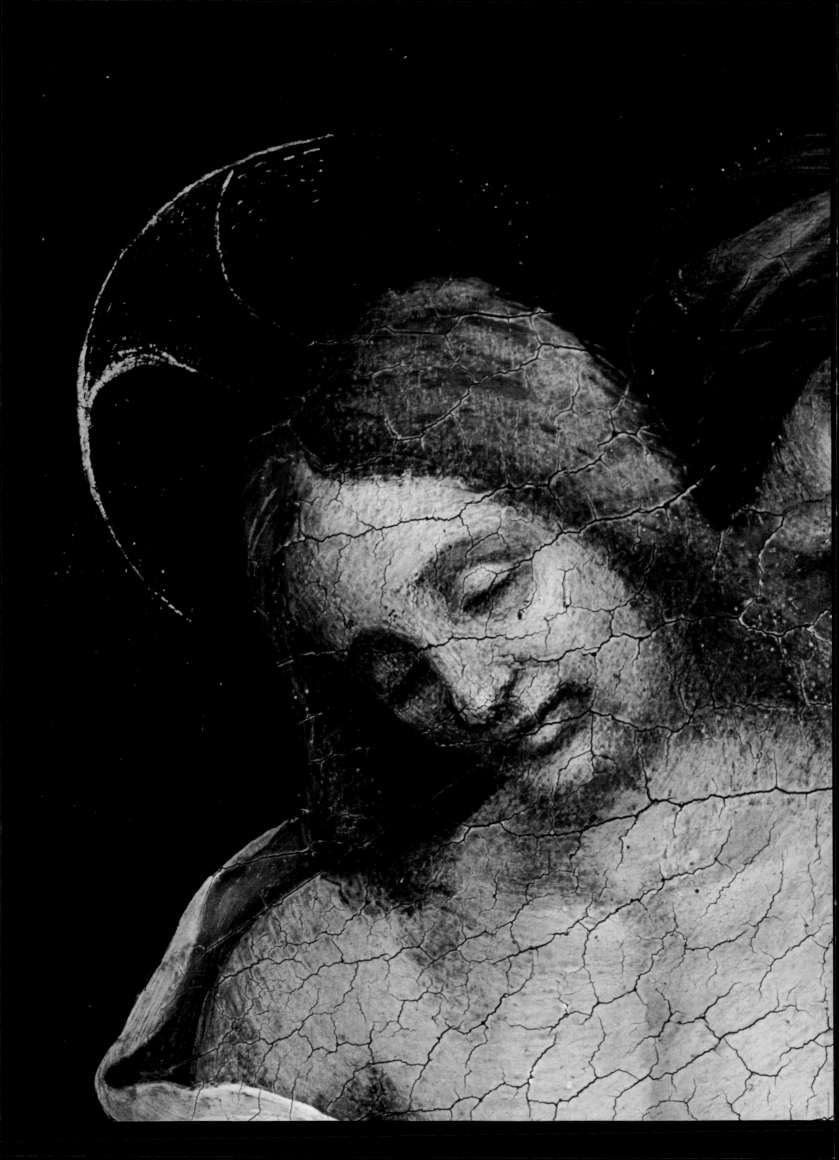

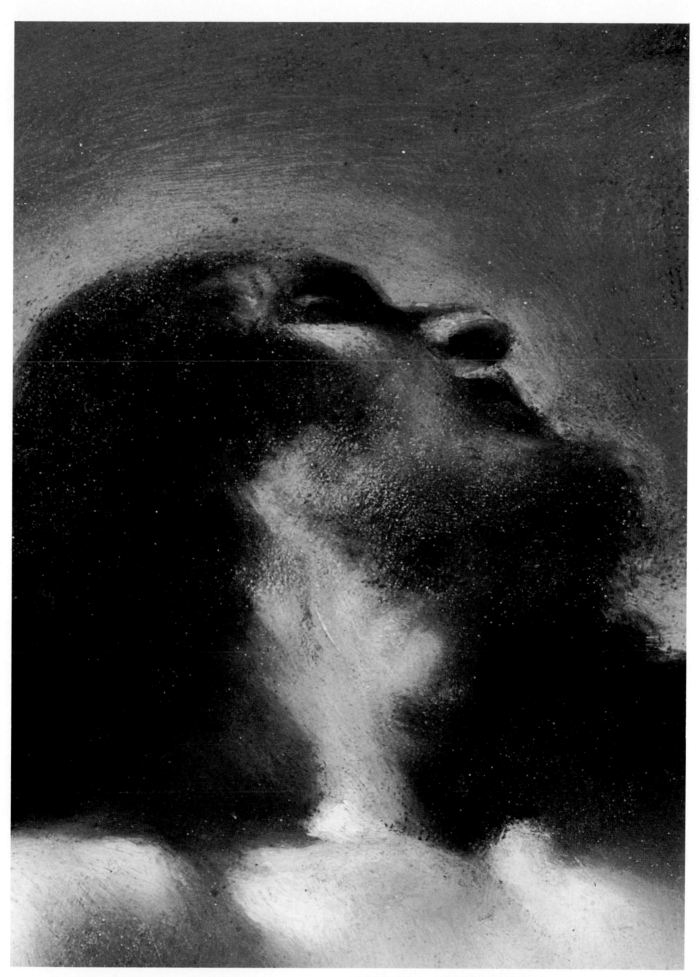

GUERCINO, *ANGELS WEEPING OVER THE DEAD CHRIST*

FILIPPINO LIPPI, *PIETA*

97

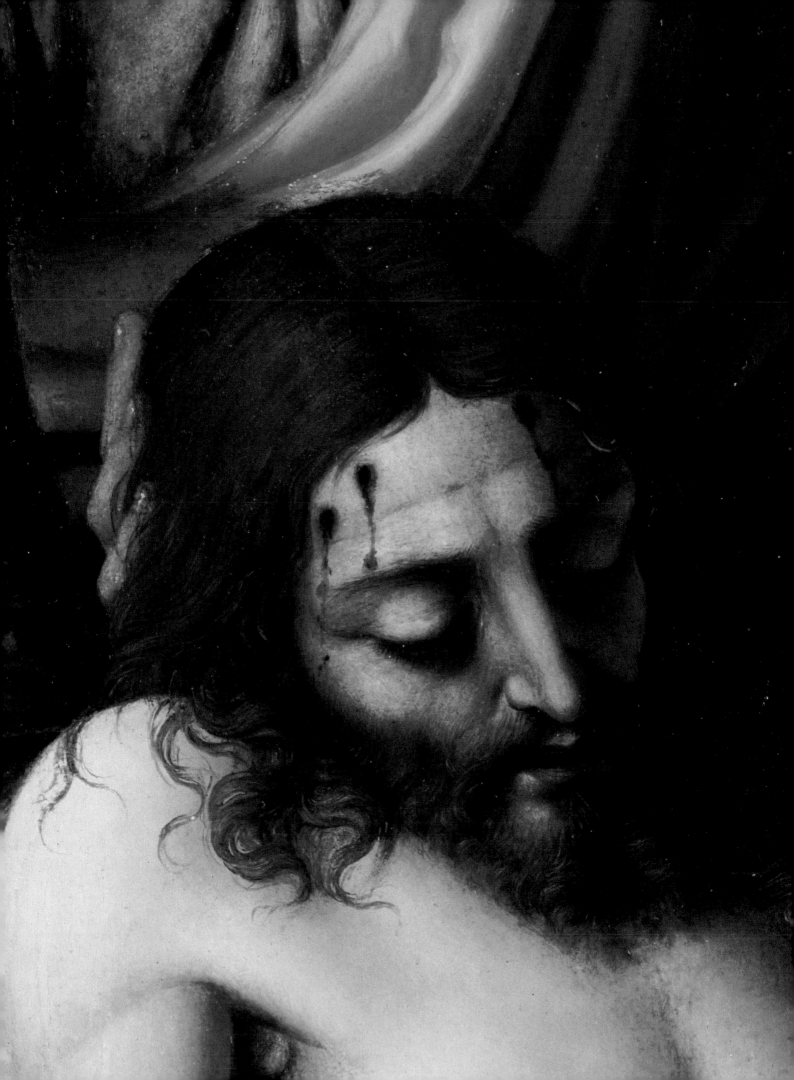

When the even was come, there came a rich man of Arimathaea, named Joseph, who also himself was Jesus disciple: He went to Pilate, and begged the body of Jesus. Then Pilate commanded the body to be delivered. And when Joseph had taken the body, he wrapped it in a clean linen cloth, and laid it in his own new tomb, which he had hewn out in the rock: and he rolled a great stone to the door of the sepulchre, and departed. MATTHEW 27:57–60

HIS TRIUMPH

In the end of the sabbath, as it began to dawn toward the first day of the week, came Mary Magdalene and the other Mary to see the sepulchre. And, behold, there was a great earthquake: for the angel of the Lord descended from heaven, and came and rolled back the stone from the door, and sat upon it. His countenance was like lightning, and his raiment white as snow: and for fear of him the keepers did shake, and became as dead men. And the angel answered and said unto the women, Fear not ye: for I know that ye seek Jesus, which was crucified. He is not here: for he is risen, as he said. MATTHEW 28:1–6

PIERO DELLA FRANCESCA, *THE RESURRECTION*

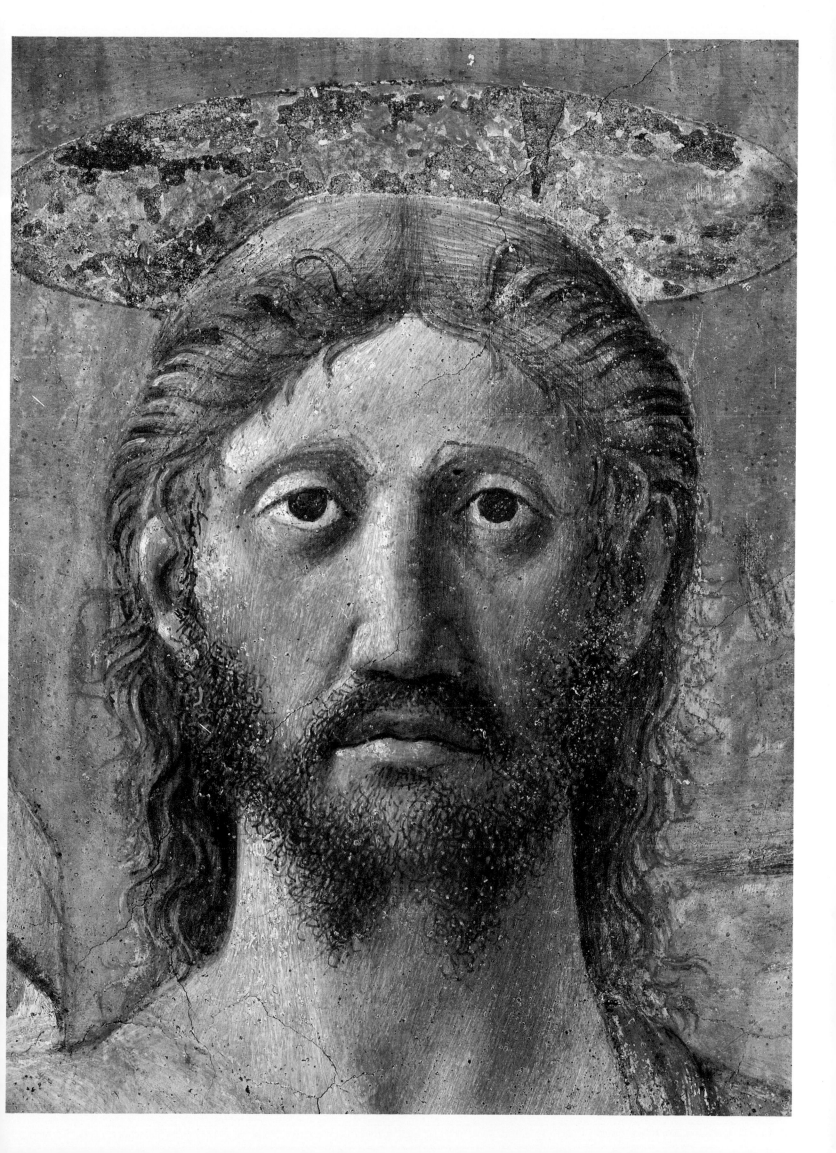

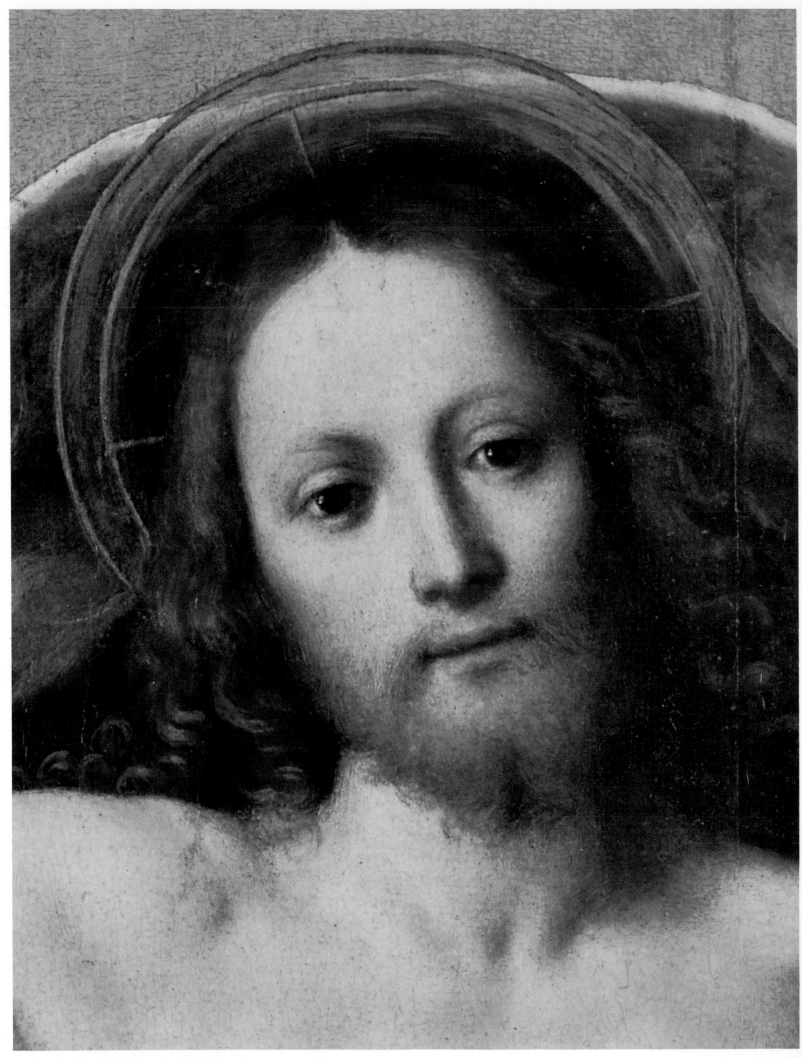

GAUDENZIO FERRARI, *THE RESURRECTION*

AMBROGIO BORGOGNONE, *THE RESURRECTION*

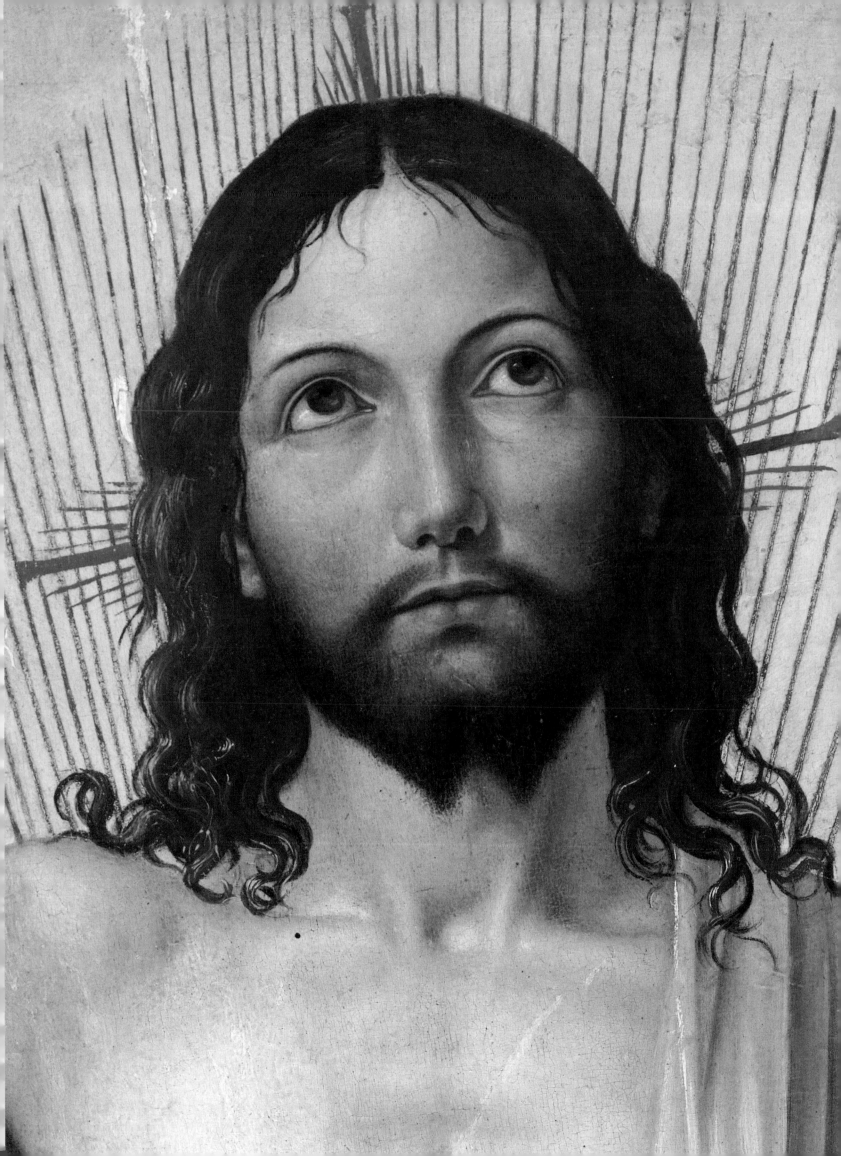

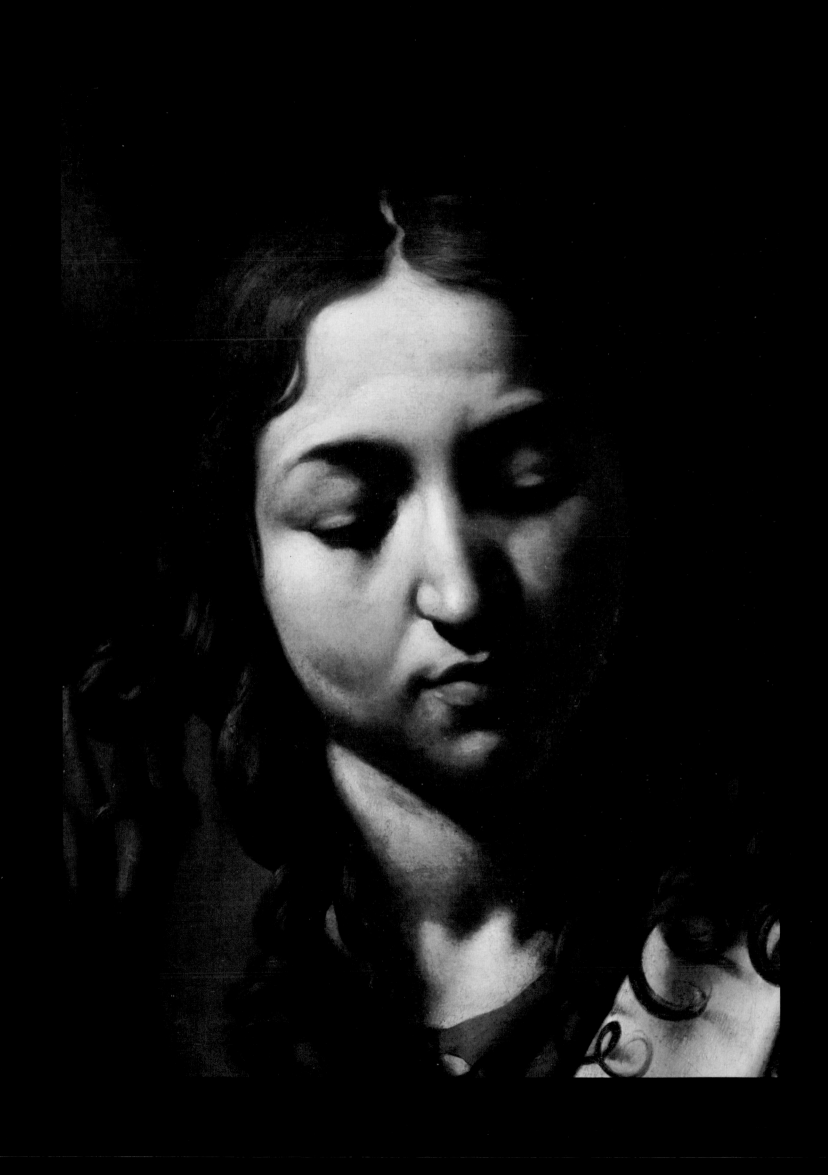

Then the same day at evening, being the first day of the week, when the doors were shut where the disciples were assembled for fear of the Jews, came Jesus and stood in the midst, and saith unto them, PEACE BE UNTO YOU. JOHN 20:19

MICHELANGELO CARAVAGGIO, *THE SUPPER AT EMMAUS*

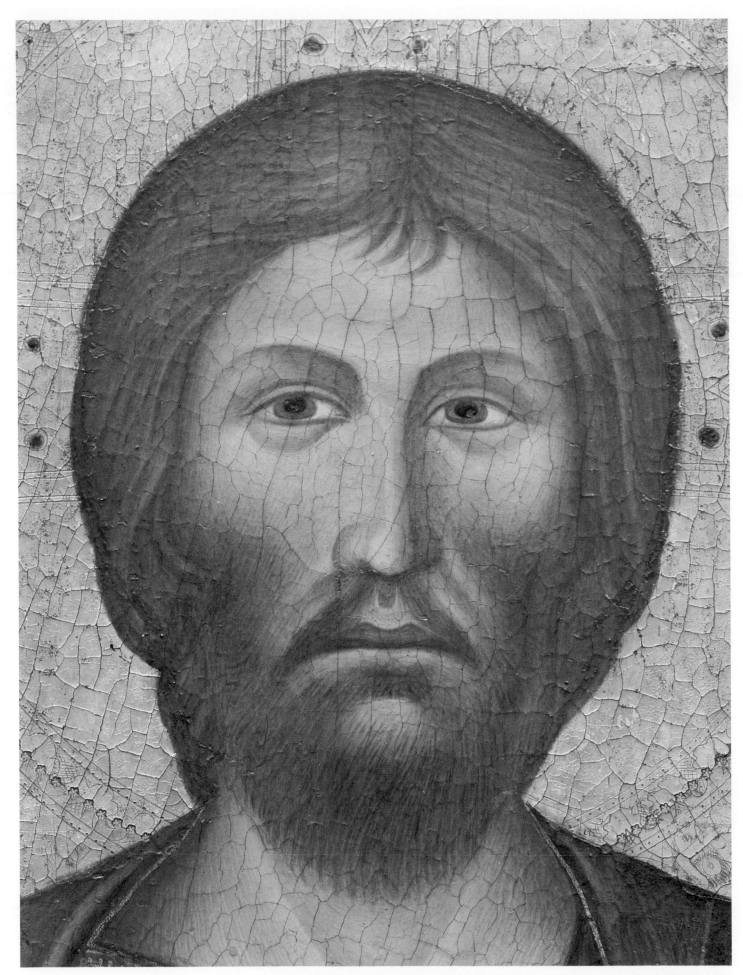

FOLLOWER OF CIMABUE, *CHRIST BETWEEN ST. PETER AND ST. JAMES MAJOR*

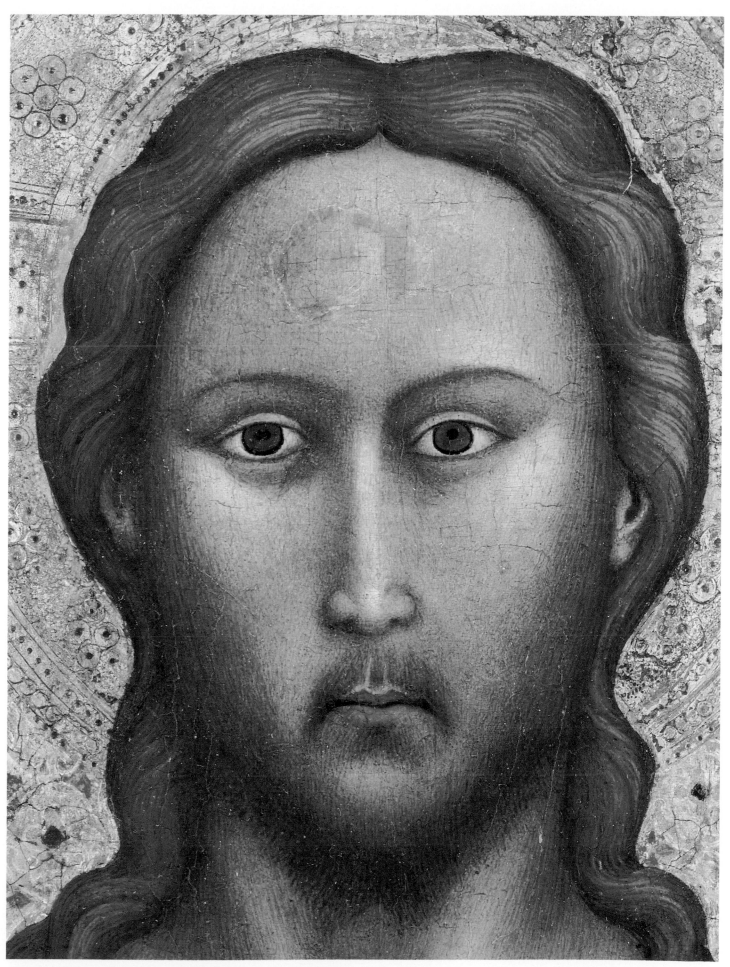

ATTRIBUTED TO TOMASSO DI NICCOLO, *HEAD OF CHRIST*

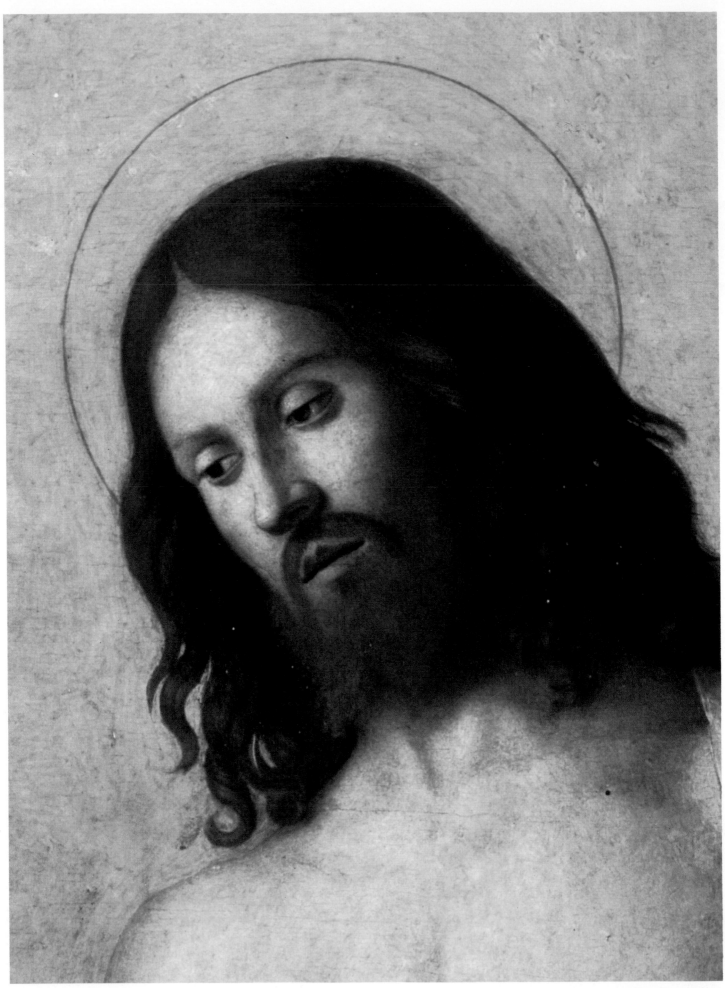

CONEGLIANO DA CIMA, *DOUBTING THOMAS*

THOMAS, BECAUSE THOU HAST SEEN ME, THOU HAST BELIEVED: BLESSED ARE THEY THAT HAVE NOT SEEN, AND YET HAVE BELIEVED. JOHN 20:29

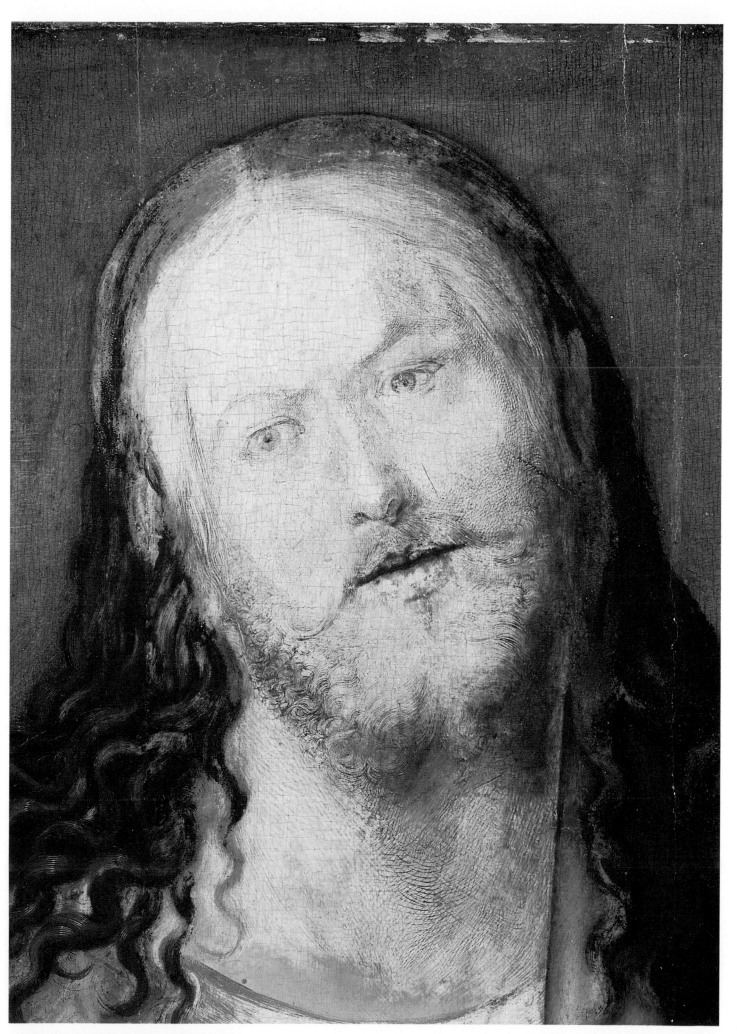

ALBRECHT DURER, *SALVATOR MUNDI*

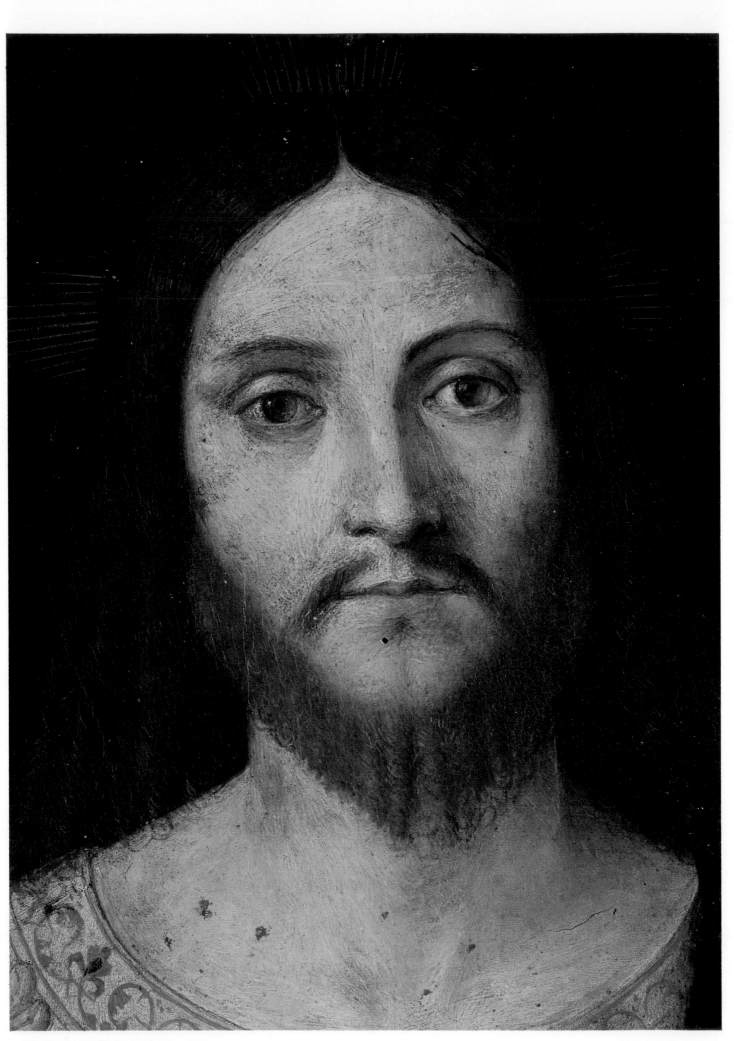

LOMBARD SCHOOL, *CHRIST BLESSING*

JAN VAN SCOREL, *BENEDICTION OF CHRIST*

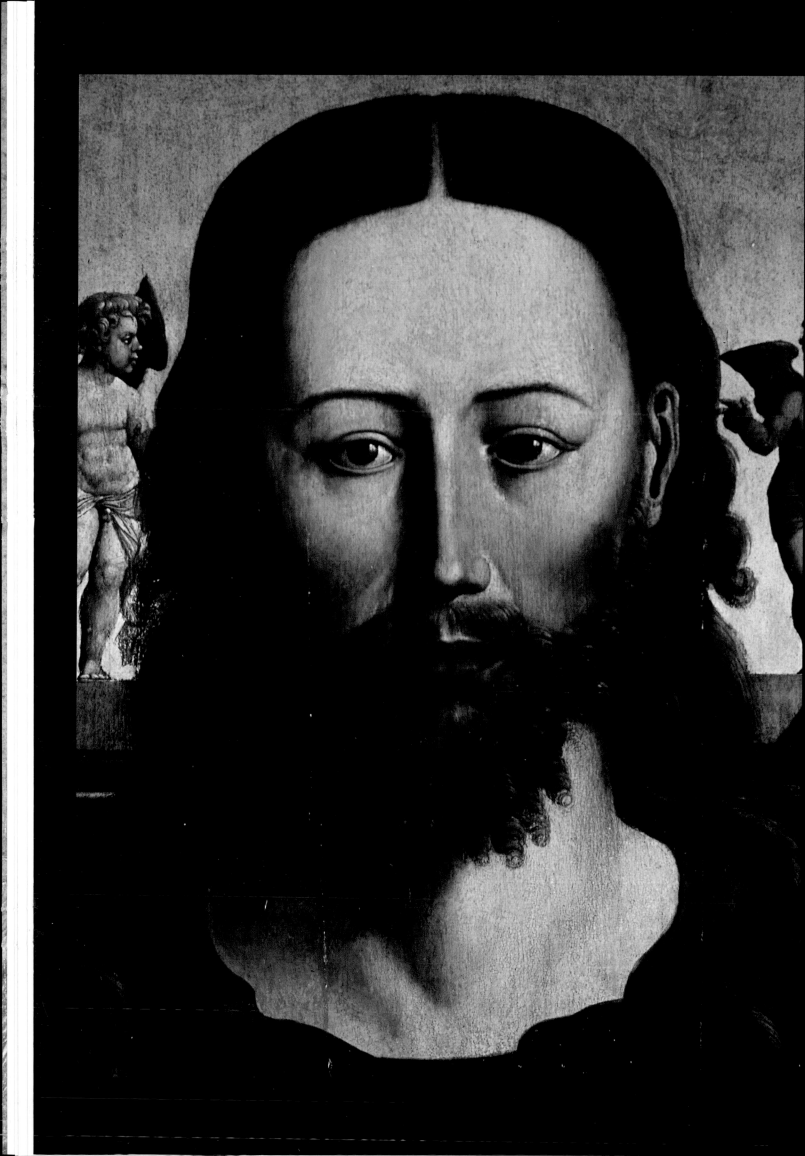

LIST OF COLOR PLATES

Note: All the reproductions in this book are details.

Left column

2.

AVID, Gerard, Flemish, active about
1484-died 1523
hrist Taking Leave of His Mother
ourtesy of The Metropolitan Museum of Art,
New York
equest of Benjamin Altman, 1913

3.

APHAEL, Italian (Umbrian), 1483-1520
he Transfiguration
he Vatican Museum, Rome
Courtesy of Stockphotos, Inc., New York

5.

AES, Nicolaes, Dutch, 1634-93
hrist Blessing the Children
ourtesy of the Trustees,
The National Gallery, London

5.

ACECCO de Rosa, Italian (Neapolitan),
c. 1600-1654
hrist Blessing the Children
ourtesy of Stockphotos, Inc., New York

7.

IBERA, José de, Spanish, 1591(?)-1562
he Savior
he Prado, Madrid
ourtesy of Stockphotos, Inc., New York

9.

L GRECO (Domenikos Theotocopoulos), Spanish,
1541/48-1614
hrist Driving the Money Changers from the Temple
ourtesy of The Minneapolis Institute of Arts

).

UBENS, Peter Paul (Flemish), 1577-1640
hrist and Mary Magdalen
lte Pinakothek, Munich
ourtesy of Scala/Art Resource, New York

1.

NTORETTO, Jacopo Robusti, Italian (Venetian),
1518-94
hrist at the Home of Mary and Martha
lte Pinakothek, Munich
ourtesy of Stockphotos, Inc., New York

2.

OTTO, Lorenzo, Italian (Venetian), c. 1480-1556
hrist and the Woman Taken in Adultery
he Louvre, Paris
ourtesy of Giraudon/Art Resource, New York

3.

RANACH, Lucas, the Elder, German, 1472-1553
hrist and the Adulteress
ourtesy of The Metropolitan Museum of Art,
New York
he Jack and Belle Linsky Collection, 1982

1.

TIAN (Tiziano Vecelli), Italian (Venetian),
1487/90-1576
he Tribute Money
ourtesy of the Trustees,
The National Gallery, London

5.

ASACCIO, Italian (Florentine), 1401-28
he Tribute Money
ancacci Chapel, Church of Santa Maria
del Carmine, Florence
ourtesy of Scala/Art Resource, New York

7.

EMBRANDT van Ryn (attributed to), Dutch,
1606-1669
ead of Christ
ourtesy of The Metropolitan Museum of Art,
New York
r. and Mrs. Isaac D. Fletcher Collection

Middle column

SUFFERING

69.

DALI, Salvador, Spanish, 1904-
The Sacrament of the Last Supper
Courtesy of the National Gallery of Art, Washington
Chester Dale Collection

70.

BENVENUTO di Giovanni, Italian (Sienese),
c. 1436-1518
Passion of Our Lord: The Agony in the Garden
Courtesy of the National Gallery of Art, Washington
Samuel H. Kress Collection

71.

BOSCH, Hieronymus (attributed to), Dutch,
c. 1450-1516
Christ Before Pilate
Courtesy of The Art Museum, Princeton University
Gift of Allan Marquand

72.

BACCHIACCA, (Francesco Ubertini Verdi), Italian
(Florentine), 1494-1557
The Flagellation of Christ
Courtesy of the National Gallery of Art, Washington
Samuel H. Kress Collection

73.

VELAZQUEZ, Diego Rodriguez de Silva y, Spanish,
1599-1660
*Christ After the Flagellation Contemplated by the
Christian Soul*
Courtesy of the Trustees,
The National Gallery, London

74.

MORALES, Luis de (El Divino), Spanish,
1509(?)-1581
Man of Sorrows
Courtesy of The Minneapolis Institute of Arts

75.

VERONESE, Paolo, Italian (Venetian), c. 1528-88
Christ Carrying the Cross
The Louvre, Paris
Courtesy of Giraudon/Art Resource, New York

76.

CARAVAGGIO, Michelangelo Merisi da, Italian,
1571-1610
Ecce Homo
Palazzo Rosso, Genoa
Courtesy of Scala/Art Resource, New York

77.

TINTORETTO, Jacopo Robusti, Italian (Venetian),
1518-94
Ecce Homo
Scuola di San Rocco, Venice
Courtesy of Scala/Art Resource, New York

79.

VAN DYCK, Anthony, Flemish, 1599-1641
The Mocking of Christ
Courtesy of The Art Museum, Princeton University
Gift of the Charles Ulrick and Josephine Bay
Foundation, Inc., through
Colonel C. Michael Paul

80.

GIORGIONE (attributed to), Italian, 1477/8-1510,
or School of Giovanni Bellini, Italian,
c. 1430/8-1516
Christ Bearing the Cross
Courtesy of Isabella Stewart Gardner Museum,
Boston/Art Resource, New York

82.

MAINERI, Gian-Francesco da, Italian (Lombard),
d. 1504/5
Christ Carrying the Cross
Galleria Doria-Pamphili, Rome
Courtesy of Stockphotos, Inc., New York

Right column

83.

SOLARIO, Andrea, Italian, (Milanese), 1495-1524
Christ Carrying the Cross
Courtesy of Stockphotos, Inc., New York

84.

PALMEZZANO, Marco, Italian, c. 1458/63-1539
Jesus Carrying the Crosss
Galleria Spada, Rome
Courtesy of Stockphotos, Inc., New York

85.

ALLORI, Alessandro, Italian (Florentine),
1535-1607
Simon of Cirene Helping Jesus to Carry the Cross
Galleria Doria-Pamphili, Rome
Courtesy of Stockphotos, Inc., New York

86.

FETTI, Domenico, Italian (Roman), c. 1589-1623
The Veil of Veronica
Courtesy of the National Gallery of Art, Washington
Samuel H. Kress Collection

87.

ROUAULT, Georges, French, 1871-1958
Ecce Homo
Modern Religious Art Collection, The Vatican,
Rome
Courtesy of Scala/Art Resource, New York

88.

DAVID, Gerard, Flemish, active about 1484-died
1523
The Crucifixion
Courtesy of The Metropolitan Museum of Art,
New York
Rogers Fund, 1909

91.

PESELLINO (Francesco di Stefano), Italian
(Florentine), 1422-1457)
The Crucifixion with St. Jerome and St. Francis
Courtesy of the National Gallery of Art, Washington
Samuel H. Kress Collection

92.

ANGELICO, Fra, Italian (Florentine),
c. 1387/1400-1455
Deposition of Christ
Museo di San Marco, Florence
Courtesy of Scala/Art Resource, New York

93.

SCHOOL OF AVIGNON (attributed to
Charanton), French, 15th century
Villeneuve Pietà
The Louvre, Paris
Courtesy of Scala/Art Resource, New York

95.

CRIVELLI, Carlo, Italian (Venetian), c. 1430-1495
Pietà
Courtesy of The Philadelphia Museum of Art
John G. Johnson Collection

96.

LIPPI, Filippino, Italian (Florentine), c. 1457-1504
Pietà
Courtesy of the National Gallery of Art, Washington
Samuel H. Kress Collection

97.

GUERCINO, Italian (Bolognese), 1591-1666
Angels Weeping over the Dead Christ
Courtesy of the Trustees,
The National Gallery, London

98.

SOLARIO, Andrea, Italian (Milanese), 1495-1524
Lamentation
Courtesy of the National Gallery of Art, Washington
Samuel H. Kress Collection

TRIUMPH

101.
PIERO della Francesca, Italian (Umbrian),
c. 1410/20-1492
The Resurrection
Palazzo Communale, Sansepolcro
Courtesy of Scala/Art Resource, New York

102.
FERRARI, Gaudenzio, Italian, c. 1471/81-1546
The Resurrection
Courtesy of the Trustees,
 The National Gallery, London

103.
BORGOGNONE, Ambrogio (Stefani da Fassono),
 Italian (Milanese), c. 1455-1523/35
The Resurrection
Courtesy of the National Gallery of Art, Washington
Samuel H. Kress Collection

105.
ORCAGNA, Andrea, Italian (Florentine),
 c. 1308-68
Noli me Tangere (pinnacle from an altarpiece)
Courtesy of the Trustees,
 The National Gallery, London

106.
CARAVAGGIO, Michelangelo Merisi da, Italian,
 1571-1610
The Supper at Emmaus
Courtesy of the Trustees,
 The National Gallery, London

109.
VELAZQUEZ, Diego Rodriguez de Silva y, Spanish,
 1599-1660
The Supper at Emmaus
Courtesy of The Metropolitan Museum of Art,
 New York
Bequest of Benjamin Altman, 1913

110.
CIMABUE (follower of), Italian (Florentine),
 late 13th century
Christ Between St. Peter and St. James Major
Courtesy of the National Gallery, Washington
Andrew W. Mellon Collection

111.
NICCOLO di Tomasso (attributed to),
 Italian, active 1343-76
Head of Christ
Courtesy of The Metropolitan Museum of Art,
 New York
Gift of Jack and Belle Linsky Fund, 1981

112.
CIMA da Conegliano, Giovanni Battista, Italian
 (Venetian), c. 1459/60-1517/18
Doubting Thomas
Accademia, Venice
Courtesy of Scala/Art Resource, New York

113.
DURER, Albrecht, German, 1471-1528
Salvator Mundi
Courtesy of The Metropolitan Museum of Art,
 New York

114.
LOMBARD SCHOOL, Italian, early 16th century
Christ Blessing
Galleria Doria-Pamphili, Rome
Courtesy of Stockphotos, Inc., New York

115.
VAN SCOREL, Jan, Flemish
Benediction of Christ
The Prado, Madrid
Courtesy of Stockphotos, Inc., New York

116.
JOOS VAN CLEVE, Flemish, c. 1485-1540/1
Christ Blessing
The Louvre, Paris
Courtesy of Stockphotos, Inc., New York

117.
MABUSE, (Jan Gossaert), Flemish, died c. 1533
Between the Virgin and St. John the Baptist
The Prado, Madrid
Courtesy of Stockphotos, Inc., New York

118.
VAN DYCK, Anthony, Flemish, 1599-1641
Christ
Stadtische Kunstsammlung, Düsseldorf
Courtesy of Stockphotos, Inc., New York

120.
Sicilian Mosaic, 12th century
Duomo, Céfalu
Courtesy of Scala/Art Resource, New York

121.
ARTIST OF THE KREMLIN,
 Armory Workshop, Russian, 17th century
Icon with the True Image of Christ
Courtesy of The Metropolitan Museum of Art,
 New York
The Rogers Fund, 1975

122.
MELOZZO da Forli, Italian (Umbrian), 1438-94
Christ
Palazzo Ducale, Urbino
Courtesy Scala/Art Resource, New York

125.
GRUNEWALD (Mathias Neithardt-Gothardt),
 German, c. 1470/80-1528
Christ Rising (from Isenheim Altarpiece)
Musee Unterlinden, Colmar
Courtesy of Stockphotos, Inc., New York

MARGARET WISE BROWN

The Good Little Bad Little Pig

Illustrated by **DAN YACCARINO**

HYPERION BOOKS FOR CHILDREN
NEW YORK

First Edition

1 3 5 7 9 10 8 6 4 2

Printed in Mexico

Library of Congress Cataloging-in-Publication Data

Brown, Margaret Wise, 1910–1952.

The good little bad little pig / Margaret Wise Brown; illustrated by Dan Yaccarino.—1st ed.

p. cm.

Summary: Peter's wish comes true when he gets a little pet pig who is sometimes good and
sometimes bad.

ISBN 0-7868-0600-1 (hc) — ISBN 0-7868-2514-6 (library)

[1. Pigs—Fiction. 2. Pets—Fiction.] I. Yaccarino, Dan, ill. II. Title.

PZ7.B8163 Gnt 2002

[E]—dc21

2001039083

Visit www.hyperionchildrensbooks.com

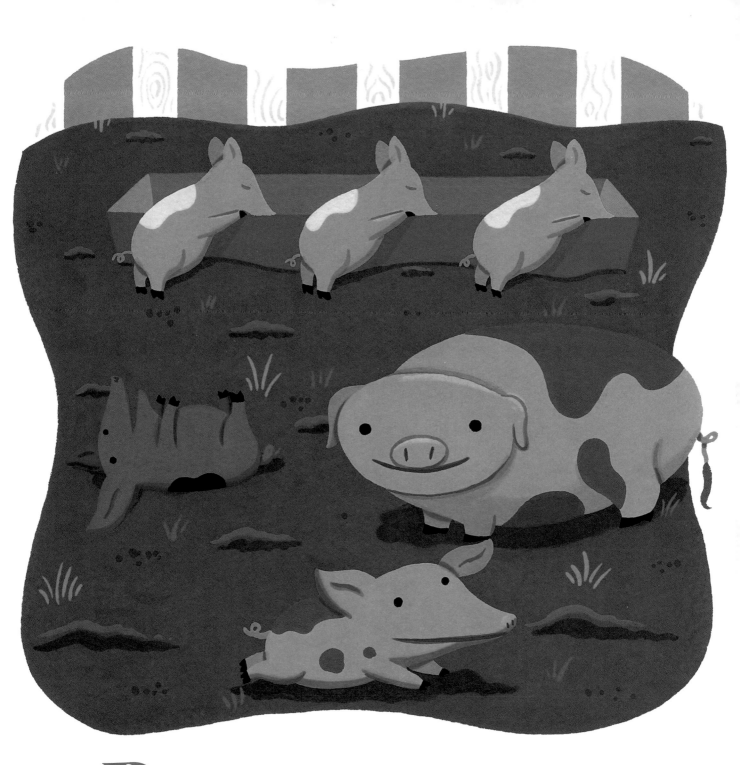

Poor little pig. He lived in a muddy old pigpen with four other little pigs and a mother sow. He was a little pink-and-white pig, but with mud all over him, he looked only partly pink.

Then one day a little boy named Peter asked his mother if he could have a pig.

"What!" said Peter's mother. "You want a dirty little bad little pig?" She was very surprised.

"No," said Peter. "I want a clean little pig. And I don't want a bad little pig. I want a good little bad little pig."

"But I never heard of such a thing," said Peter's mother. "Still, we can always try to find one."

So they sent the farmer who owned the pig a letter:

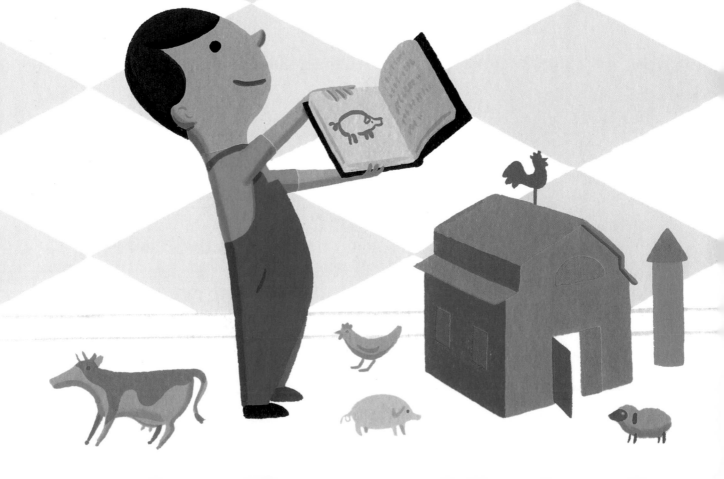

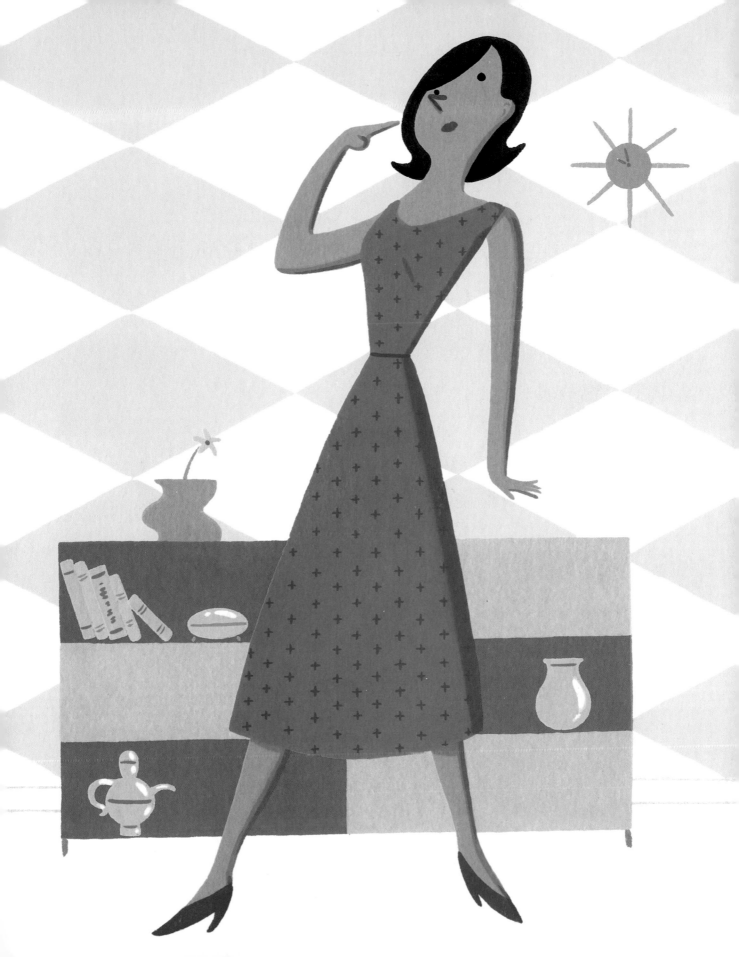

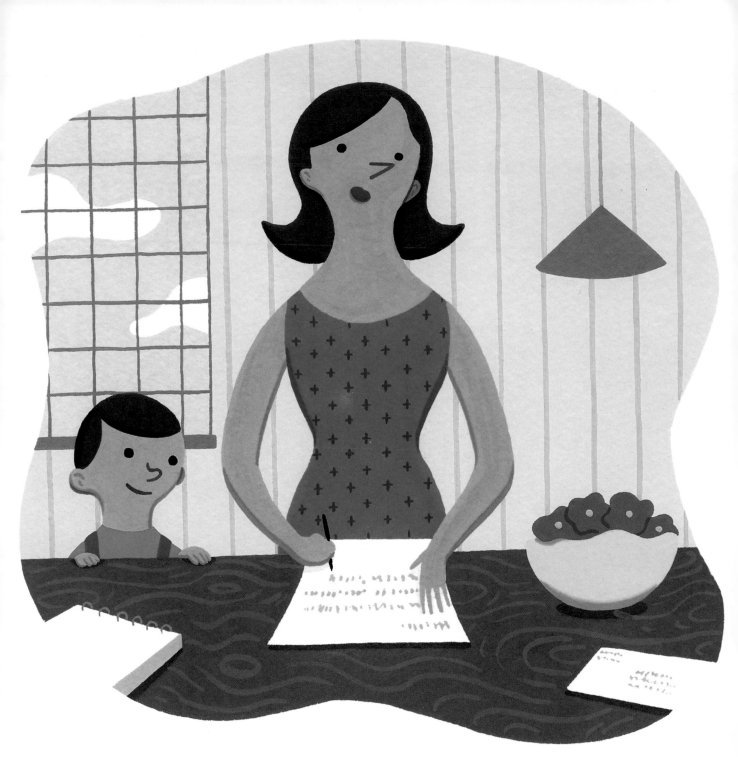

"Farmer, farmer,
I want a pig—
Not too little
And not too big

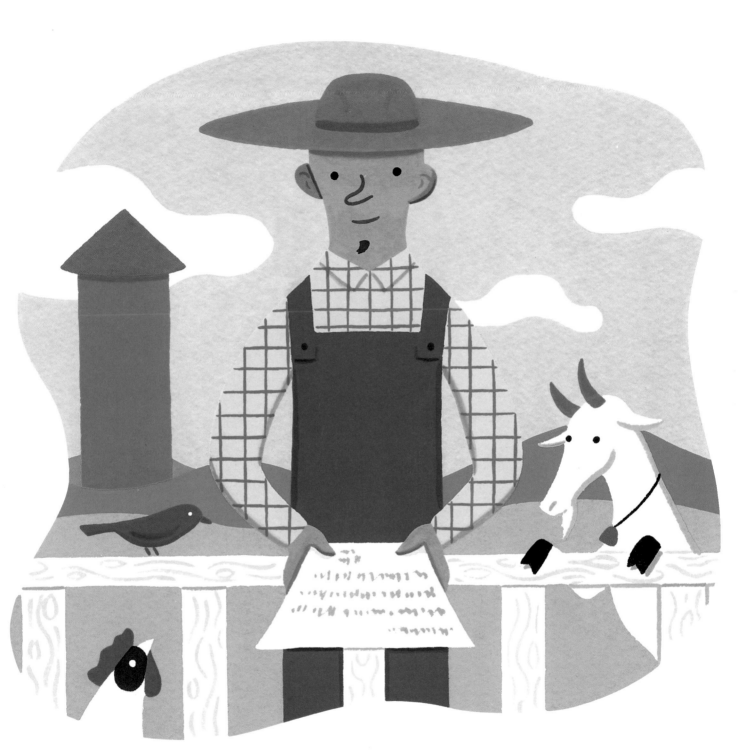

Not too good
And not too bad—
The very best pig
Any boy ever had."

The farmer read the letter, and then he went out to the pigpen and looked at the five little pigs. Three little pigs were fast asleep. "Those," said the farmer, "are good little pigs." And one little pig was jumping all around. "That," said the farmer, "is a bad little pig."

And then he heard a little pig squeak, and then he heard a little pig squeal. But when he looked, there was just one little gray-pink pig standing in an old tin pan in the corner of the pen. "That," said the farmer, "is a good little bad little pig." So the farmer sent the pig to the little boy.

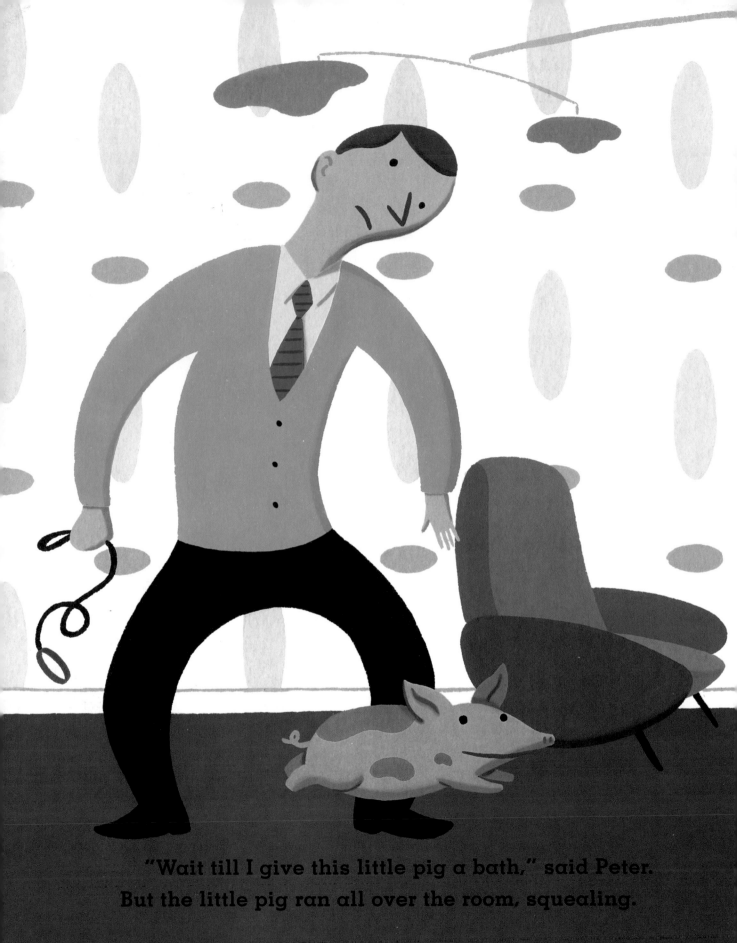

"Wait till I give this little pig a bath," said Peter.
But the little pig ran all over the room, squealing.

"Squeeee ump ump ump."
"What a bad little pig!" said Peter's father.

"Wait," said Peter, "until the little pig knows us. He is not a bad little pig."

The little pig stared at Peter out of his dark squint eyes, and then he shook himself and trotted after Peter.

"What a good little pig!" said Peter's mother, as she came into the room with a pan of food for the little pig to eat after his journey.

"Wait," said Peter. "Remember, this is a good little bad little pig."

The little pig started eating.

"*Galump gump gump gump,*" he grunted. He was making a mess.

"What a bad little pig!" said Peter's father. "What terrible eating manners he has!"

"But he does enjoy his food," said Peter.

"Yes," said his father, "he does enjoy his food." And he beamed with a smile all over. "What a good little pig," he said. "He has eaten up everything in the pan."

"Come on, you good little bad little pig," said Peter. "I will give you a bath so you will be a clean little pig."

So Peter went into the bathroom and put the little pig right into the bathtub and let warm water run all over him. The little pig squealed and squealed

and wiggled around. Peter took a big cake of soap and rubbed it all along the pig's back until he was all covered with pure white soapsuds. Then he took a scrubbing brush, and he scrubbed and scrubbed. Then he rinsed off the pig's back with warm water until he was all clean.

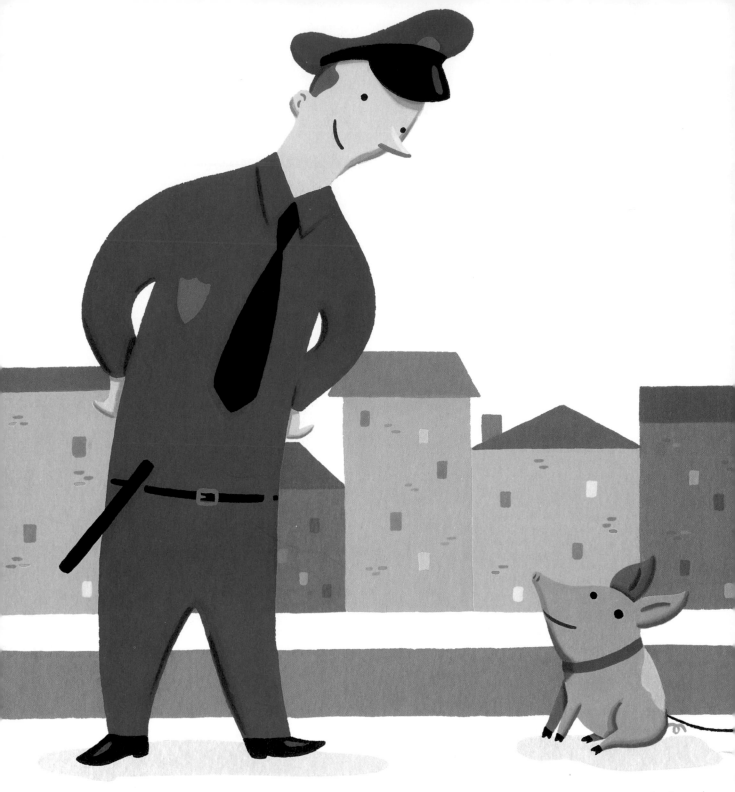

Then Peter dried him with a great big bath towel and took him for a walk in the sunshine.

"Look," said Peter as he showed his little pig to the policeman. "Did you ever see such a fine little clean little pig?"

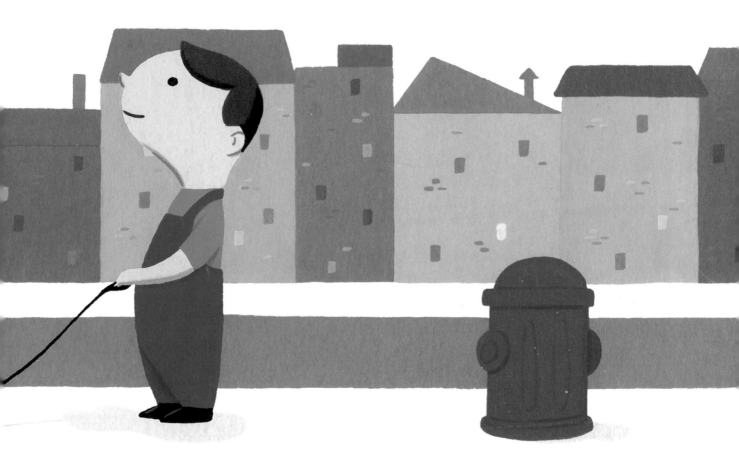

"I never did," said the policeman, "see such a good little pig." And he blew his whistle and stopped all the automobiles so that Peter and the little pig could get across the street.

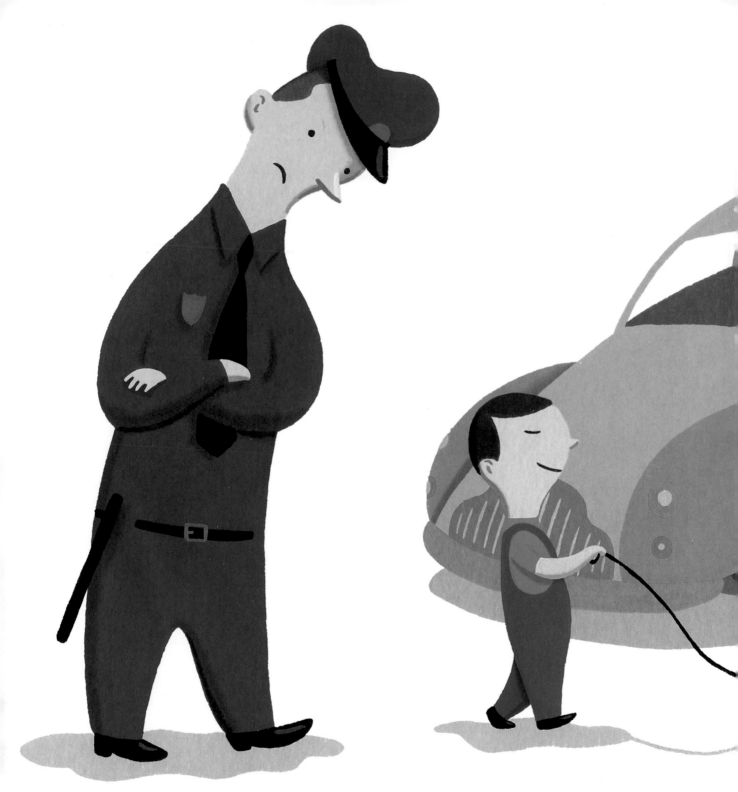

"You pull him, Peter," he said, "and I'll get behind him and push." So they did. And when they got to the middle of the road, the little pig trotted along just as nice as you please.

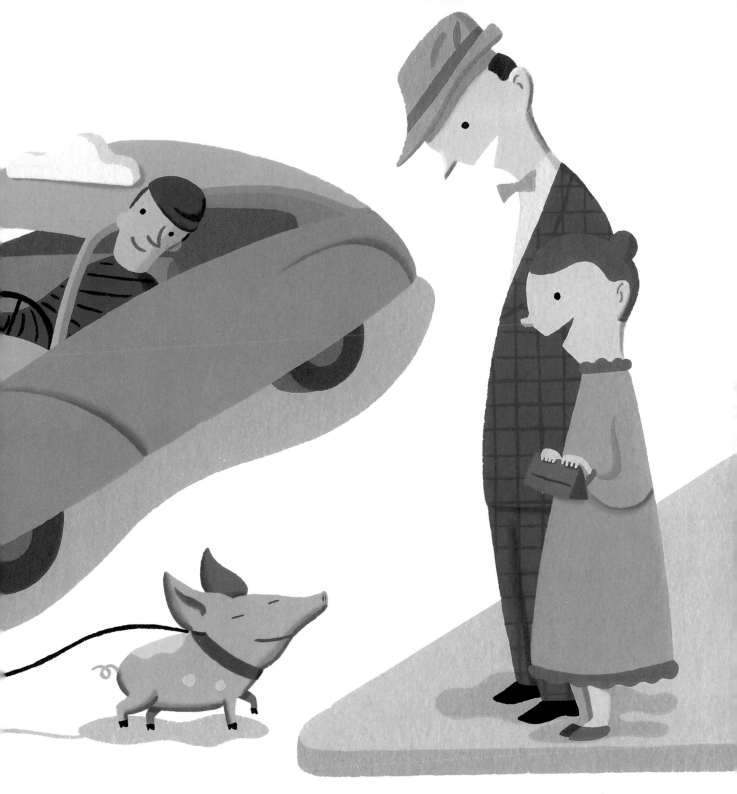

"What a good little pig," said the people on the other side of the street.

And so it was that Peter got just what he wanted—
a good little bad little pig. Sometimes the little pig
was good and sometimes he was bad, but he was the
very best pig any boy ever had.